Tur

Turbaned Tornado

The Oldest Marathon Runner Fauja Singh

Khushwant Singh

Foreword by
Capt. Amarinder Singh

RUPA
PUBLICATIONS INDIA

Published by
Rupa Publications India Pvt. Ltd.
7/16, Ansari Road, Daryaganj,
New Delhi 110 002

Sales Centres:

Allahabad Bengaluru Chennai
Hyderabad Jaipur Kathmandu
Kolkata Mumbai

Printed in India by
Nutech Photolithographers
B-240, Okhla Industrial Area, Phase-I,
New Delhi 110 020, India

CONTENTS

FOREWORD

I first had the opportunity to meet Sardar Fauja Singh in December 2004 when we invited him back to Punjab to lead commemorative marathon run from Chamkaur Sahib to Fatehgarh Sahib on the Martyrdom Tercentenary of Guru Gobind Singhji's brave Sahibzadas.

This legend of a man, who has only recently celebrated an entire century of the seemingly impossible on earth, surprised all of us with his quiet simplicity, purposefulness and single-minded commitment to his chosen sport and way of life.

Fauja Singh's unprecedented achievements mark a never before triumph of the human spirit and it makes me more than proud that I share with him a common heritage – one that is rooted in the fertile Punjabi hinterland and infused with a zeal that never gives in.

This biography, written by my young friend Khushwant, chronicles perhaps only a part of Fauja Singh's sporting brilliance. But it significantly constitutes the priceless impressions of a man who has witnessed an entire century, spanning two world wars, India's struggle for Independence and the often tumultuous blossoming and maturing of Indian Democracy all the way up to this exciting new age of computers and information.

Fauja Singh witnessed history as it happened. And being the man that he has shown himself to be as also perhaps keeping pace with our fast changing times, he chose to quite literally run his way across the last 15 years!

But for me this great marathon man's biggest accomplishment is in the immeasurable inspiration and motivation his life and the way he continues to live it, brings for generations of young people in Punjab, India and the whole world.

In what no one could possibly rightly refer to as 'the twilight of his life', Fauja Singhji happily runs races to inspire young and not-so-young Punjabis to forsake drugs and instead turn to sport.

I applaud his spirit, thank him and wish him good health and many more marathons. I also congratulate the author for giving us such a rare and close glimpse of a living legend.

<div align="right">

Capt. Amarinder Singh
Moti Bagh Palace, Patiala

</div>

ACKNOWLEDGEMENTS

Sincere thanks to my wife, son and parents who have yet again tolerated another non-profitable venture! A note of thanks to Jasvinder Singh, Managing Director, GNA Axles Punjab, for his support; Harbinder Singh Rana, Director, Anglo Sikh Heritage Trail, for his continuous backing and Harinder Singh, proprietor of retail store 1469.

A humble thanks to Fauja Singh's coach Harmander Singh, sons Sukhjinder and Harvinder for providing an insight into their father's life.

A special thanks to the Singh twins, Amrit and Rabindra for providing Fauja Singh's image for the cover. The image is from their painting 'EnTWINed' which is part of the Museum of London collection.

PREFACE

The first time I met the world's oldest half marathon runner Fauja Singh was in 2005, when I was working on my first book, *Sikhs Unlimited*. It was one of those meetings that leave a lasting impression and become an important milestone in one's life.

Fauja Singh, 94 years old then, was wearing a blue suit with a tie which had images of marathon runners printed on it. He was in his sports shoes which had his name 'Fauja' and 'Singh' printed on them.

In the first few minutes of our introduction itself, Fauja had made it clear that he was an illiterate, and I should not expect any words of wisdom from him. He in the same breath had also announced the day's itinerary, which included a ten mile walkathon.

My second meeting with Fauja was in May 2010, after his coach Harmander Singh asked me if I could write Fauja Singh's biography to commemorate hundred years of the living legend. His reason for asking me to write was because he had felt that my write-up on Fauja Singh in *Sikhs Unlimited* was the most authentic till then. However, Harmander had only one condition – that I don't exploit his trainee!

With a promise to use the royalties towards a good cause, I had set off on my journey to the UK to meet the great Fauja once again. The journey was no less than a pilgrimage.

Fauja had not changed. Though he could not place me, as so many writers and journalists have interviewed him over the years, the consistency in his talk, behaviour, eating habits and value system amazed me as we repeated the same journey we undertook five years ago.

Turbaned Tornado is the result of spending endless hours with the runner, his family, coach and others who have been influenced by Fauja's life. It traces the runner's roots and tries to capture his life's journey and understand the impact of Fauja on the world around him.

In short, it is a humble attempt to confine in words the life of a man whose spirit is indomitable.

If I have been able to capture even an iota of Fauja Singh's invincible spirit in this book, I think, I have achieved my goal then.

1

EARLY LIFE

1 April, 1911

They in their wildest dreams did not know that 1 April was a fool's day. But if the soothsayer would have told farmer Mehr Singh and his wife, Bhago Kaur that their newborn son with spindly legs would be running long distance races at the age of 99, they would have surely kicked out the soothsayer from their home, calling him a fraud who was trying to fool them for extra money.

Hundred years later, when the achievements of Fauja Singh are narrated in the drawing rooms of Punjab's rich landlords and under the banyan trees of Punjab villages, folks still say, 'unbelievable.'

But Fauja Singh's story is no folklore. It is a true story of an old Sikh man who started running at an age where many do not even reach and went on to achieve superhuman feats.

But this Punjabi 'Forrest Gump' has not hung his running shoes yet, as he still feels he has miles to go before he sleeps. And mind you he has not read Robert Frost.

Born in Bias Pind, then a nondescript Punjab village on the present Jalandhar-Pathankot road, Fauja was the youngest child of his poor parents who bore four children.

Fauja, meaning army, got his name after women family members, on a full moon night, had heard someone call out 'Oye Faujiya' while performing the *parikrama* (circumambulation) of the Golden Temple, Amritsar, the holiest Sikh shrine. The women folk who had gone to the temple for a pilgrimage had instantly pledged to name the next male child in the family, Fauja.

Fauja, or Fauju as he was called in his early days, much to the dismay of his parents was not a blessed child. He was rather a non-starter, given that he started walking only at the age of five.

'Children of my age would play the cycle tyre game, (running the tyre with a stick on the non-metalled village lanes), whereas I would sit like a cripple, watching them play,' says Fauja while describing his childhood days. 'So spindly and weak were my legs that my friends in the village teased me by nicknaming me *danda* (stick).' Matchstick looking legs apparently are a genetic trait in Fauja's family as his whole family was called the *danda* family. Interestingly, the family still jokes about their spindly legs but the taunt is usually centred around Fauja. Fauja recalls how surprised the blonde masseurs were when they saw his legs after a marathon in Toronto. The sight had left them baffled that, how could this old man manage so much, with so little flesh on his legs.

Seeking medical help was a rarity in the early twentieth century British Indian villages. Families relied more an additional medicines than visiting professional doctors. And, given Fauja's health condition no one in the family gave him much chance at athleticism. They did not even consider that as an option. But to be fair to Fauja's

biological parents and his Aunt Rai Kaur who had adopted him when he was about five, no one actually gave much importance to sports in those days even if the child showed promise. But they had held religious prayers and distributed the holy *prasad* (food distributed on religious occasions) to thank the Almighty when Fauja had started walking.

However, that was not the end of the child's agony. So frail was Fauja in health, that he could barely walk a mile till the age of fifteen. 'My legs were so weak that I could not even walk a mile. Perhaps it was Almighty's way of preserving them for later years,' says Fauja taking comfort from the fact that nature has its own ways of equalising.

2

GROWING UP

Schools were few and the nearest one was a few miles away, in the neighbouring village of Alawalpur. Given his poor health and the parents' ignorance about the benefits of education, studies unfortunately never came in Fauja's way. '*Moya koi school janda si uhna dina wich* (no one went to school in those days),' remarked Fauja, a bit surprised over the question about his education.

No school meant, neither regular school friends, nor regular games for him. The games children played in those days were the indigenous village games like *gulli-danda* (a traditional Punjab game played with wooden sticks), kabaddi and tug-of-war. One of Fauja's favourite game while growing up was jumping into the well-beds of newly constructed wells which at that time were the only source of water for the village. Young boys would assemble around a partially finished well and one by one jump on the soft soil bed and the children who were scared to jump, were pushed by Fauja. He was notorious in the village for being extremely naughty, a characteristic that has not eluded him at all!

Recalling an episode from childhood, Fauja says: 'There was this one guy who just wouldn't jump into the well whereas I had taken my turn five or six times. Ultimately I pushed him as he stood on the edge contemplating his move.' That the incident was recited with a dash of choicest Punjabi expletive goes without saying, as expletives are an integral part of Punjabi vocabulary, especially in villages. Incidentally, Fauja had caught up with the same friend who now lives in Coventry, where he had gone to run for a child charity. Kartar Singh according to Fauja has grown very old. 'But I did remind him of being pushed into the well when I'd gone to attend one of his great grandchild's birthdays recently,' added Fauja.

The other pastimes those days in the village included climbing trees, which Fauja did like a monkey and spending hours in the village common area or *deodi,* playing cards and gossiping, an occurrence that has not changed much since the last ten decades. Except that, today's youth are dressed in denims and shirts instead of the traditional *kurta-pyjamas* and travel more on motorcycles and scooters. Youngsters still can be seen wiling away their precious time. As for gossip they are yet to beat Fauja Singh's story-telling abilities as he besides being called *danda* (stick) was also the most *gaallri* (talkative) and wittiest boy of the village.

Bias Pind, originally comprised seven *pattis* or localities namely – Udhopur (where the family house of Fauja Singh is located, a small *pucca* house perched on the highest point of the village), Harbans Pur, Dargu Mohan, Patti Fanaich, Patti Khasa (originally Khalsa) and Patti Upplan. The seventh one was Patti Joga but all its residents had perished in the 1902 plague and the property had then been distributed amongst the residents of the surviving six. There were no televisions or radios; life was slow and existence was on a day to day basis.

With no infrastructure to support agriculture in the early twentieth century, Fauja started working on the fields, helping his father on the farm. The agriculture of those days was dependent on oxen and rain and the staple crops were maize and wheat. The farmer would plough the field with the oxen tied in front of the plough and then sow the seeds. Then the wait for the rains would start. The harvest would depend on the monsoons which would reflect on the lifestyle of that particular year. Fauja's father's early death also became a reason that he lent his hand in the fields and supported the family. '*Huh, kehti pooch da hai* (huh, you ask me about agriculture in those days)'. Two Punjabi expletives followed. 'Agriculture, of those days was nothing but jostling with the soil,' he remarked when asked about the kind of farming he indulged in. But Fauja jostled a bit too much as it was a normal sight in the village, though much to the disgust of his family members, to see Fauja move around in a set of soiled clothes comprising a long underwear and *khaddar kurta*, woven by the womenfolk of the house.

However, despite the circumstances, Fauja was still one of the best farmers, a role-model farmer in his village. He was considered the hardest working and could plough the fields throughout the day, changing his set of oxen every few hours. He had a set of four very well-groomed oxen, and his maintenance of animals is still legendary in the village. He was of the belief that, if care was not taken, the farmer would be the ultimate loser as the animals would not be able to give full output as per the intake of the fodder. The only thing available in bountiful would be dung, as per *Faujanomics*.

3

FAMILY

Marriages happen at an early age in villages. And surely Fauja was no exception to the rule. Though no official record of his wedding date exists, it was Gian Kaur, of village Kalkat from the neighbouring Hoshiarpur district in the doab area of Punjab, who was selected to be his wife. The wedding ceremony was simple and was performed according to Sikh religious rites at the village temple.

Fragile Gian Kaur was from a modest home and equally illiterate. She performed the duty of a home-maker, her main responsibilities being looking after the children, house, kitchen and the cattle. Even though means to support a large family were meagre, Fauja had six children: three boys and three girls. In those days, having many children was an accepted fact but later parents had to strive really hard to make both ends meet.

The first child they were blessed with was a girl, and they named her Gurbaksh Kaur. Two more girls followed at short intervals and were named Jaswinder Kaur and Parminder Kaur. The urge to have a boy, an attitude that still prevails in modern Punjab, was

also one reason for a permanently pregnant Gian Kaur. The fourth child thankfully was a boy and the family named him Sukhjinder. Kuldip followed and another came a few years later and the family named him Harvinder.

With a large family to support, Fauja could never dream of splurging whatever little he earned and kept his indulgent habits under control. For example, though he would regularly drink alcohol but never went overboard, not exceeding 120 ml at any given time, a figure that is actually considered medicinal in Punjab. Though a near teetotaller now, Fauja does consume an occasional peg of Black Label Scotch to relax his tired muscles, but realises the disadvantages and ill effects of alcohol. 'I at times do buy one bottle of Black Label from the super-market and have a peg once a week,' said Fauja when asked was he a teetotaller in the real sense. '*Ik adhi la laina haan, kyonki jey mein pivaan gaa, they bhaj thodi sakda haan* (I am a teetotaller, except that I consume one peg a week. I cannot run if I drink),' he adds giving an honest reply, the hallmark of his personality.

To keep physically fit in his younger days, Fauja preferred eating health food, even though fruits and vegetables were scarce in those days as a result of which he depended a lot on milk and milk products like *kheer, lassi* and yogurt, the latter being still his staple diet. His favourite fruit was mango and till date Fauja cannot control his craving for mangoes. Even today he must spend 50 pence a day on a mango during the season.

Ninety something, Bakshish Singh, a retired wireless operator from the Indian Army and one of the few villagers alive who has played and interacted with Fauja during growing up years claimed that Fauja was blessed with the ability to judge what kind of food

suited him and what would harm him. 'He was a boy blessed with a lot of common sense, even though he went to school just for a few days,' said Bakshish Singh who feels privileged to have known Fauja since childhood. 'Though our village has seen intense migration abroad in the last 60 years and every household has at least one member abroad, but it is because of *Fauju* that our village is recognised internationally,' he adds. 'If I tell people I am from Fauja's village, they stop asking about my welfare and start inquiring about Fauja and his early times.'

What Bakshish probably is unaware about is that there is a full-fledged Facebook profile under the name 'Roots in Bias Pind' which proudly displays the great Fauja on the profile picture. Other than this, there are groups by the name Fauja Singh which have over 25,000 fans from all over the globe and still counting. Some of the fans on the friends list are physically challenged people who claim that Fauja's feats are keeping them motivated. Countless comments on running sites like runnersworld.co.uk show the impact of the man on aspiring runners as well as runners who share the Fauja affect and drool over the indefinite running capability of the Sikh from England.

Pundit Krishan Lal, who runs the oldest provision store in the village is the other contemporary alive and has vivid memories of Fauja. Parkinsons afflicted Lal, is full of stories of childhood days but claims that there is no story on Fauja's flirting habits since he (Fauja) never went to school and college. 'All these things used to happen only in cities and unfortunately Fauja did not go to school,' he said. He, however, chose to remain discreet despite being probed repeatedly by Fauja's son Harvinder to narrate how the village *baazigarnis* (a tribe), especially Mungo would tease Fauja whenever

she stopped by his fields to collect fodder for her cattle. Kishan Lal had snubbed the collected crowd and put the record straight by saying, 'Barring the natural urge that a growing up teenager experiences, Fauja never did a thing that would attract a complaint'. Incidentally, Fauja still holds this quality in high esteem and has been constantly engaging himself, to raise his social behaviour. According to him, his endeavour, ever since he has been in the public gaze, has been that no act of his should bring a bad name to his children.

So proud is the village of the runner's feats that it wants to preserve everything that has a Fauja stamp on it. Be it, memories from his childhood days and stories about his journey to fame or material things if someone is in possession of them. And as per Fauja's own words, *Mittran da naa chal da, jithon marji vanga kadha laiye*, which literally means ask about Fauja's house to anyone in the village and he would proudly guide you to Fauja's *dera* (the family has shifted from the village house to a farmhouse on the outskirts), where his youngest son now lives and farms.

4

CHANGE

Being uneducated himself Fauja did not see much worth in education. As a result, none of his six children got beyond basic education. But people in the *doab* (land between two rivers) of Indian Punjab by now had developed a plan B. The West had been discovered and migration to pursue the dollar dream had assumed the status of frenzy in this part of Punjab. For unskilled labour to emigrate to the West in those days was considered *de rigeur*. Rather, an economic compulsion, given the poor infrastructure and job opportunities Punjab offered. The girls went abroad through marriage and young men to pursue their dollar dream took any recourse, be it legal or illegal. And Fauja was no different in his belief, settling five of his six children abroad though he himself remained in India for most part of his life before finally immigrating to UK in the mid 1990s. 'We were not Maharajas in India, otherwise why would we want to leave our homeland,' said Fauja who despite being highly sought after in the UK, misses his home. But at the same time he is fully aware that Fauja the icon would not have come into existence *sans* the move.

Life was at a subsistence level and '*main taan hal challa challa margaya* (I spent my entire life tilling land with oxen),' he said in chaste Punjabi summing up his economic condition in one line, a trait that has remained glued to Fauja since childhood. 'Son, it is only now that things have improved back home otherwise *dhakke hi khaade hai* (I have had a tough life). There were no roads, no potable water, sand all over, and now there is *bhadiya sadak* (good roads), cars, motorcycles and tube-wells,' he said drawing comparisons of Punjab between then and now, the present thriving because of NRI remittances.

Time ticked quickly and the children were growing up fast. As it was in previous generations, girls in rural Punjab continued to be married early. Fauja's immediate concern was also to marry off his daughters and settle his sons. Jaswinder Kaur, the second daughter was the first child to get married. She got married to a UK based Indian and she presently resides in Nottingham. She is mother of four children. Gurbaksh Kaur, the eldest was married a few years later in Punjab but died soon after giving birth to her third daughter. Parminder Kaur was the third child to take the auspicious four rounds around the Holy Sikh book, *The Guru Granth Sahib*, which (rounds) as per Sikh rituals are mandatory to become husband and wife. She is settled in Vancouver, Canada and Fauja visits her often. Sukhjinder Singh, the fourth sibling and the eldest amongst the sons soon found himself in the UK, in search of greener pastures.

Three sons could not live off a small patch of land and new avenues had to be explored. After putting in years of struggle, Sukhjinder today leads a comfortable life with his wife Amarjit Kaur whom he married in the UK itself. He runs a plumbing business

and resides in Seven Kings. The next one to get married was his son in the village, Kuldip Singh while the youngest Harvinder Singh, was trying hard to get a grip on life in the West. However, an unforeseen tragedy was to find Harvinder back in India tilling his ancestral property in place of Fauja's fifth child Kuldip who was killed in a freak accident just outside his house. This untimely occurrence transformed Fauja's life forever.

5

TRAGEDY

It was the August of 1994 and the monsoon winds were in a tearing hurry, as 40-year-old, Kuldip Singh monitored the construction of a roadside *dhaba* (cheap roadside restaurant) on the Jalandhar–Pathankot road. The *dhaba* was a new venture he was starting and it was located just opposite the *dera*, the house where Kuldip stayed with his father since 1984. Fauja and his son had everything going for them. A tractor, a symbol of pride and affluence in Punjab had been purchased recently and the family had added more acreage to their small holding by taking land on lease. That this venture would cost Fauja more than money was something he had not foreseen. In its hurry, the wind had picked up an iron sheet from the roof of the *dhaba*, displaced it from its position, and flung it at Kuldip Singh's head, killing him instantaneously. All hell had broken loose.

Fauja's wife Gian Kaur's (1992) death a few years ago had not impacted Fauja as much as the death of his lad. Fauja, in fact, had accepted his wife's death with grace since hers was a life well-lived. The practical man that Fauja is, he was aware that under normal

circumstances two old people usually do not die at the same time. It was the death of young Kuldip Singh that had crushed his soul forever. 'I was devastated,' he says. 'You love all your children equally, but you develop a special bond with the child with whom you have lived all your life. With Kuldip I had established just such a bond, since all the others had migrated abroad,' said Fauja, his voice getting emotional, an indication that the tragedy has refused to leave him even after two decades of its occurrence.

Fauja as per the village folks and close associates had lost complete interest in life after the tragedy. The man in whom manifested the Punjabi *joie-de-vivre* had suddenly turned into a stone. His zeal to live had touched its nadir. He would pick up a fight or an argument with everyone on the slightest pretext. Friends started disassociating with him, for he no longer was the same Fauja. The situation was compounded when he had to part with his granddaughter (Kuldip Singh's daughter) who shifted to her maternal grandparents' house with her mother. Till date, this one thing has pierced this octogenarian's heart and even though so many years have passed, he still has this one desire that his granddaughter come back to her father's house. He would roam around the village aimlessly or sit for hours weeping near the tragedy site.

Bakshish Singh, whose house is close by to the village cremation ground recalls innumerable occasions where he had had to fetch a wailing Fauja from the cremation ground. He would slip in the dark and sit next to the spot where his son's pyre was lit and keep talking to himself. This continued till as recently as 2008 when Fauja came for his annual visit to the village.

Phones had buzzed and urgent telegrams scripted with the message that the old man had lost it, reached his son Sukhjinder

in England and his daughter in Canada. Friends advised that the only solution to save him from depression and death was to take him away from the village for some time. After serious family consultations during Harvinder's wedding (married six months after Kuldip's death), Fauja was taken to England by his son Sukhjinder but Fauja had rejected the change and returned to his village. Apart from feeling shackled he was worried about the farm and did not have much faith in his youngest son's agriculture abilities since Harvinder had barely worked on a farm earlier. On reaching India, he obviously was exposed to the same environment, as a result of which the mood swings returned. This time he was more moody than before.

According to Fauja, even twenty years after his son's death, he does not have the courage to glance at his dead son's picture. A nephew visiting India from USA suggested to Fauja Singh's daughter in Canada that the old man's survival was only possible if he was re-located abroad permanently with either one of his children. Family again headed for India to persuade Fauja to return to England. Fauja Singh can be a very stubborn man and has his own outlook towards life. He does not compromise easily on his freedom even till this age. 'If I'm confined to a clock what is the use of my living? I'm a free bird – a free soul. Try controlling me and I'll buck like a stallion,' he said explaining his concern over the captivity of the soul he would have to experience if he shifted abroad.

6

NEW BEGINNING

Fauja, after much persuasion and pressure agreed to return to the UK to his son Sukhjinder in 1995. This time, however, things worked out better for him in England. He made friends around and started socialising in the Sikh temples in the vicinity. His illiteracy was a hindrance in the new world, but being an intelligent man, Fauja soon found his way around with food, people, travel and a daily routine.

Describing his early days in the UK, Fauja claims to have forgotten his home address many times. He soon realised that, unlike the life in Indian villages, where you have people taking out time to take you around, life in the UK was different. No one had the time to take him around as everyone was busy in their work. Fauja, who has respected work since childhood did not hold this lack of attention as a grievance and sorted out his life himself. 'In this country, never ask someone to take out time. It is the biggest crime.' Comparing work cultures, Fauja quipped, 'In India if you feed someone with whiskey and food for ten days, he will ignore his work and wile away his time with you, unlike in the West, where

people cannot afford to miss work. They would prefer to give you 100 GBP for your travel than being asked to break their routine which affects the entire economy.' Another one of his *Faujanomics*. For many months, Fauja roamed like a lost lamb, but soon started recognising not just the bus numbers, but also the company logos of those that would take him home. However, to be on the safer side, he always carried a visiting card in his pocket.

Freedom was around the corner. Soon he started getting invitations to weddings and other Punjabi socials in the Ilford area, his old habit of *gaallari* coming in handy for his day to day existence. 'Like company is important for a child, it is equally important for an old man. For an old man to pass his time, he needs good company,' said Fauja, explaining how sometimes he would travel miles to attend a function despite his illiteracy. 'I would carry the invitation card and tell the taxi driver to take me to the address mentioned, after which I would relax,' he said. During his social interface, Fauja soon found the company of one Lahmber Singh, a kabaddi player. He joined their group to begin training on his fitness, and introduced bursts of jogging in his walking strides. That these strides would give him wings, Fauja had no idea.

7

RUNNING

Though Fauja was not much of a television buff in India, Punjabi radio and the idiot box became his other companions in the UK, which according to Fauja, was an otherwise dull country especially for those who came from a non-English speaking background. It was while surfing television channels that he saw scores of men and women running for hours together. Intrigued over this aimless running, he inquired from his peers what it was all about. After being told that it was a marathon, in which runners were to complete a long distance of 26 miles and 385 yards (42.195 kilometres), Fauja had shown keen interest in giving this road race a shot.

The name Marathon[1] comes from the legend of Pheidippides, a Greek messenger. The legend states that he was sent from the battlefield of Marathon to Athens to announce that the Persians had been defeated in the Battle of Marathon (in which he had just fought), which took place in August or September, 490 BC. It is said that he ran the entire distance without stopping and burst into the assembly, exclaiming 'Νενικήκαμεν' (Nenikékamen, We have won.')

before collapsing and dying. The account of the run from Marathon to Athens first appears in Plutarch's On the Glory of Athens *in the 1st century* AD, *which quotes from Heraclides Ponticus's lost work, giving the runner's name as either Thersipus of Erchius or Eucles. Lucian of Samosata (2nd century* AD) *also gives the story but names the runner Philippides (not Pheidippides).*

An opportunity for Fauja to try his endurance came his way in 1999 as there was a 20 mile run near Ilford for the benefit of cancer patients. Since there is no record to substantiate Fauja's story, it should be taken with a pinch of salt. But since it comes from the runner's own mouth, it establishes a crucial link to Fauja's running escapades. It is not to suggest that Fauja didn't run or to doubt the occurrence of the event, but it is to bring to attention that Fauja has no idea about timelines, distance (more so when he started his career) or the context of the events. For example, the BBC has interviewed him innumerable times and he only recalls them as a company whose loudspeaker runs all over the world. He has no recollection that a short biography was written on him in a book titled *Sikhs Unlimited* and that this author had spent a couple of days with him five years ago. But then this is the real Fauja – unmindful of the legend he has become and of the indelible legacy he would leave to history. Though over the years he is more aware of his achievements, various interviews have consistently reflected that what keeps Fauja going is his conviction that he would die the day he hangs up his shoes.

Certain that his daily routine consisting of a bit of exercise was sufficient enough to see him through this distance, Fauja and a few other friends enrolled their names for the race. One was Dhillon from Bhatinda district in South Punjab and the other a woman from

Gujarat, who was to become a pillar of support for Fauja in later years. According to Fauja, there were about 200 participants in the race and as the race progressed, many folks had started quitting, whereas he had held his ground and kept running. Even his friend Dhillon, according to Fauja, had to take the sweeper bus to reach the finish line. Narrating more about his race experience, Fauja said that he had to use the washroom after about eight miles and couldn't find one for long. There were more pubs and no toilets, he explains laughingly – the pub culture of Britain.

To cut the long story short Fauja, who had completed the distance with a fair amount of ease, was convinced he could run a complete marathon. Research suggests that the distance Fauja ran was twenty kilometres and not 20 *meel* (the Punjabi term for miles), as suggested by him. Perhaps he was not able to differentiate the nomenclature of miles and kilometres. In his naïveté, he presumed 26 miles would be a cakewalk since a full marathon was only six more miles.

8

TRAINING

Fauja, besides being defiant and stubborn, is a very determined fellow. Perhaps it is a combination of these three qualities that has given him this longevity and the ability to accomplish derring do feats at this age. According to Fauja, only two kind of people run marathons – those who are mavericks or God's true disciples. Fauja, after having successfully completed the 20 miles (so he thought), was now determined to have a go at the upcoming marathon and the closest to where he lived was the Flora Marathon.

Of such high quality was the determination that nothing was going to prevent him from not running it. Not even the fact that it was already October and he was extremely late to register himself and there was no hope for him to run. But Fauja would take none of it and convinced that *juggad* (Punjabi word for fix all) could be worked here like back home; he started approaching community and religious leaders, politicians, Members of Parliament, and other influential people, urging them to get him an entry. He put his thumb impression on many applications that were forwarded to the organisers requesting them to give him a slot, but luck was

not favouring the brave as a waiting list number was all he got in spite of so many recommendations.

Just when hope had started fading, Fauja was introduced by Jeevan Singh Mangat, a local businessman, to one Harmander Singh, a physical trainer and veteran marathoner who was to later become Fauja's mentor. A messiah sent by God himself. Seeing Fauja's determination and desperation to run the marathon, Harmander realised that the only way to achieve Fauja's dream was through a Golden Bond whereby charities pre-bought a fixed number of places for a fee. Charities then passed it on to individuals who could raise more money for the respective charity. On being asked what kind of charity he would like to run for, Fauja had shown his desire to run for the most vulnerable of the lot after which Harmander Singh approached BLISS, a charity for premature infants. He requested them to grant one pass to Fauja and BLISS promptly agreed to have an old man of 88 keen to run for the charity as it gave them a good strap-line also. Oldest running for the youngest! May they live as long as him!

On receiving a letter that he could run the race provided he contributed 1400 GBP to the charity, an elated Fauja ran to his son's shop. Sukhjinder, surprised over the letter, immediately promised his father that if it brought him joy and he was convinced he could run it, he would be more than happy to contribute for the cause. It was a great moment for Fauja and not even once did he convert the currency into Indian rupees as that would have held him back. Coming from a poor background, the currency was equivalent to 1 lakh Indian rupees and he hadn't run a marathon before. It would have been a sheer waste of money from Fauja's point of view if the thought of failure had crossed his mind.

From the sequence of events it can be easily concurred that God had a plan for Fauja. He wanted him to live, travel and serve as his emissary for charity. Fauja's mistaking twenty kilometres for miles and his introduction to Harmander Singh, followed by an invite to run, could well be interpreted as coincidences, but it wouldn't be off the mark to suggest that things were unfolding as part of a greater design.

In the runner's own words – 'It is a false impression that man carries that he is everything. Man is nothing. It is the Almighty who shapes his life.'

9

FIRST MARATHON

By the time the formalities, which included paper work and raising 1400 pounds, had been completed, February 2000 had turned up on the calendar. In other words, barely ten weeks were left to prepare for the marathon in April and Harmander Singh's assessment was that Fauja had not run the 20 miles he thought he had since the statistics did not match. And if it was only 20 kilometres, the coach realised it was merely half the distance and hence concerns whether Fauja would be able to take the full marathon, a punishing event, started mounting.

However, trying to convince Fauja that he would have to double the effort and not just run those extra six miles would have proved counterproductive, as it could have shattered his confidence permanently. But then both of them came from a religion (both were Sikhs) where retreating was considered cowardly and Harmander's motto to inspire people to give their best at whatever they wanted to do became the basis on which the training regime commenced. Lo and behold! The training started under strange circumstances as Fauja turned up in a three piece suit, his dress sense making

it clear to the coach that Fauja was far away from becoming a world-class athlete. When his coach had tried to persuade him to remove some of the layers, Fauja had retorted with the line, 'I'll catch a chill.' 'Relax, you'll get warmed in a bit,' the coach had said to make his student comfortable with the idea of undressing. But you can trust Fauja with the unexpected as a) he had never been trained professionally, and b) his clothing was an attempt to be in sync with the mainstream fashion.

Due credit should be given to Fauja that in spite of being uneducated and coming from a totally rural background in India, Fauja has made an attempt to dress the way the majority of the people of his adopted country do. However, this does not imply that he has shunned his traditional *kurta-pyjama*, and his clothing habits and fetishes are discussed in a later chapter.

The first and foremost task was to undress and then re-dress him in appropriate clothing in order to make his running experience more comfortable. What you wear for a 26.2 kilometre race can be the difference between a great running experience and a bad one. Besides being comfortable and suitable clothing, in a country like England where weather has the temperament of a woman, it is recommended to be prepared for any inclemency given the time it takes to complete a marathon. And once that was achieved, Fauja was driven by his son, each Sunday morning to the coach's house in nearby Ilford. He was put through a rigorous routine which would ensure his fitness to run a marathon.

The training venue was Redbridge, Essex, about 2.5 miles away from the coach's house. It was a well thought out training venue for various reasons and Fauja till date trains at the same venue. As part of warm up exercise Harmander and Fauja would run up to

Redbridge, where a route of two kilometres had been earmarked, where Fauja would run laps alongside other exercises. Then as a warm-down, both would run back home the 2.5 miles. Though running was on the pavement on a suburban street of modest looking houses, the route at Redbridge according to Harmander was ideal for training marathon runners. The start near the BUPA hospital was uphill, so it stopped runners from running too fast early on and risk losing their stamina at the onset. Then there was a decline and then flat land ending with a quarter of a mile uphill. The more laps you did, the better stamina you built. During the first day of his training, Fauja completed one lap in about 18 minutes at 9 minutes a kilometre. For Harmander it was neither encouraging nor discouraging. But then Fauja had a zeal that was unparalleled and it was left to Harmander to capitalise on it.

Slowly and steadily, the coach who ran alongside introduced him to hill training, adapted his running style and regulated his breathing. By the end of ten weeks, Fauja, who could barely do five laps to start with, could, now complete seventeen to eighteen laps and at a much quicker pace. Since Harmander had a busy schedule, he could only train him on Sundays, encouraging Fauja to practice on his own during week days. Son Sukhjinder volunteered to help Fauja during weekdays and started practising with his father when the coach was not around. The countdown had begun as Fauja turned 89 on 1 April.

The following week his determination and faith in Waheguru would be put to test at one of the most prestigious marathon events in the world. Initiated as a charity marathon by former Olympic Champion and noted journalist Chris Brasher and Welsh athlete John Disley in 1981, the London Marathon is one of the top five

marathons run over the world today with the traditional distance of 42 kilometres and 195 metres. The race is currently sponsored by Virgin Money and is called the Virgin London Marathon. Previously, from 1996-2009, it was sponsored by Flora and was called the Flora London Marathon.[1]

Much to the disappointment of Fauja Singh, when he turned up for the marathon, he met a US citizen (Abe Abraham) older than him. It crashed his hopes of being the oldest marathon runner in that race. However, they extended courtesies towards each other, shaking hands at the start line. Abraham, a veteran of a few marathons, also gave Fauja some advice on running a marathon. Fortunately, Fauja did not understand a word of what had been said and stuck to the rules suggested by his own coach. He completed the race in 6 hours and 54 minutes and 42 seconds, an hour ahead of the American. At 89, Fauja had found a new career.

10

BREAKING BARRIERS

For a child who could not walk till the age of five and barely managed proper walking till the age of fifteen, running a marathon at the age of 89 was not a bad accomplishment at all. A BBC story dated 16 April 2004 stated that he started running in his Punjab village but stopped after the 'pain of the Partition of India in 1947', has probably been lost in translation as whatever little running Fauja did was in his late teens or early twenties. His usual answer, when he is asked when did he run first, is 'rauliyan to phehle', which, if literally translated, means before the mayhem of Partition. But the manner in which Fauja replies to this question conveys a sense that it was much before 1947, the year when India was divided into two. The Partition is just used as a timeline as it was the practice of those days to use events instead of calendars.

This also breaks the myth that Fauja had stopped running due to the pain of the Partition, as according to him, the Partition had no bearing on him or his family's lifestyle as they were unaffected by it. The village, as per the elders, had not witnessed any violence

since there were hardly any Muslims. However, they recall one stray incident of graffiti being painted, but other than that, the village folks had held their nerves and remained in their human form, unlike other areas where people were vying for each other's blood.

Encouraged by his running feat at 89, Fauja had desired to run again. The hugging blondes, the ensuing publicity and the acclaim Fauja received from the community had fuelled the desire further as he attempted to bury his grief through running. 'I had enjoyed every moment of it,' said Fauja, recollecting his first full official marathon. 'The joy I got on completing the race and the money I raised for the premature babies was encouraging and I did not want to stop', he added, vividly remembering his first full marathon.

After resting for a few months, Fauja's daily routine soon started undergoing a change. It was no more an attempt to just wile away time, but had a purpose now, which involved lot of physical work and discipline. He was also invited by various Sikh organisations, which hold sport events almost throughout the year, to run short distance races and motivate youngsters.

Incidentally, Fauja Singh not only participates in these events in the UK, the USA and Canada, but returns to his village every year to take part in the village's annual festival, which also has many sporting events. Fauja's favourite game is the 'catch the rooster' which is peculiar to sport tourneys in Punjab only. The game is usually for older folks where a rooster is let loose and the old fogs run after it to catch it. The person who manages to catch it gets to take home the rooster for evening curry, along with a cash award and a bottle of whiskey. Fauja has been winning this game for some years now, though the cash goes to the village fund and the booze is for the parched throats of his friends.

If asked what Fauja does for a living, the joke in the village is –'he catches *kukkars* (Punjabi for rooster).' That one year of sincere training would turn Fauja into a serious athlete was not something that had been fathomed, but the following year's Flora Marathon was to prove otherwise. He not only was the oldest participant in the 2001 London Flora Marathon, but he set a new record for the age 90 category. Fauja, who maintained his previous year's record of completing the race in 6 hours 54 minutes, created a record in the 90 plus category. No one else in his age bracket had completed a marathon in less than 7 hours 52 minutes. Participating for a charity for the elderly this time, since he had wanted to help as many people he could, he had knocked 58 minutes off the world's best and a new world record had been set. Fauja had made the headlines and suddenly, there was interest in Fauja.

The calendar turned quickly. Fauja, without losing focus, kept training, each step cementing his belief that age was no barrier in running. Mind you, at his critical age, each passing week ages you faster than it would have fifty years ago, but here was a man who was defying logic with each passing day. Fauja had turned 91 on 1 April 2002, but his zest to have a go at that year's London Marathon was indefatigable. To everyone's surprise he beat his own record and completed the race in 6 hours 45 minutes, shedding nine minutes of his previous time. A new record had been set and Fauja now was known by many names. Some called him the Sikh Superman; others said he was a Turbaned Tornado; while some called him the Running Baba (old man). There were a few who called him the Gritty Great Grandfather, given that he was a great grandfather and, some associated him to the movie character Forrest Gump.

In the same year, his coach registered his name for the Great North Run between Newcastle upon Tyne to South Shields. One of the toughest half-marathon courses in the entire world where one or two men die every year (four died in 2005), Fauja Singh completed the race in 2 hours 39 minutes. It was the first time a ninety one-year-old had finished a mini-marathon in less than three hours. Records were falling like nine pins. The Sikh image was being enhanced with every step Fauja took. And, since Fauja seemed to be in prime health, a target was set by his coach. The target was to complete a half marathon in two and a half hours. Though Fauja made a valiant attempt in the following year's Glasgow City Race, he fell short by three minutes (2 hours 33 minutes).

And as it happens sometimes, certain elements within the community were suddenly jealous of Fauja's glory. Supported by other envious folks, noises started emerging from various quarters that Fauja Singh might be consuming drugs to run. 'It has not been easy for me to reach where I am today,' claimed Fauja. 'Friends and people from my own community complained that I consumed drugs and ran. I had to undergo dope tests to clear my name. Ask these fellows – a Punjabi abuse follows – if I look like an addict to them. I am a God-fearing person – talk about drugs!'

The year 2003 was not far and it promised to be a busy and taxing year for the runner. Keeping his routine at Redbridge, for Fauja to run three full marathons in the year no one could imagine, as marathons can take a toll even on young people. To train and garner the determination to run a distance of 42 kilometres thrice in a year at the age of 92 is something beyond the realm of an ordinary soul. Participating in the Flora London Marathon the fourth time in a row, Fauja Singh beat his own record and finished the

race in 6 hours 2 minutes, wiping off 43 minutes from his previous record. What it meant was that anyone over ninety, who desired to be a record holder, had to beat Fauja's competitive running time. Realising 6 hours 2 minutes was not good enough for his self-esteem, and moreover that any physically fit 90-year-old could beat this record, Fauja was running his best in the next marathon that he ran in the same year (2003) in September.

Toronto, one of the most multi-cultural cities of the world and one of the lands that Punjabis have ghettoised in the last century, is where Fauja ran the second race of the year. Whether it was the Punjabi euphoria at the marathon; or simply the man's own motivation to better his own record; or the beautiful flat, fast and lakefront marathon course that made Fauja run the way he did, records suggest that on 28 September 2003, 92-year-old Fauja completed the Scotia Toronto Waterfront Marathon (STWM) in 5 hours 40 minutes, becoming the only 90 plus man on the planet to have completed a marathon in under six hours. Yes, 5 hours 40 minutes only, shocking the organisers and the running world. With such awe was this feat seen that organisers re-measured the course, just in case.

In another cracking achievement on the same day in the same race, a mining engineer, Ed Whitlock, created a new world record in the 70 plus category by completing the marathon in 2:59:10 seconds to become the only septuagenarian to go under the magic 3-hour barrier. As if God had decided to be at every marathon himself, the world record for the Marathon was set in Berlin. 'The marathon's Greatest Day! New World Records in Berlin and Toronto,' boomed Amby Burfoot's headlines in *Runner's World* magazine. Calling it 'A Day for the Ages,' it said that Whitlock

and Singh astonished the world, not only by expanding the limits of what seniors could do, but by providing inspiration for people of all ages. Here was everyone's granddad breaking 3-hours, and a great granddad completing a 42 km, full marathon in less than 6 hours. Both became the everyday superstars, the talk of the global running community and the toast of the town. 'A 92-year-old guy called Fauja Singh just made everyone in Toronto look like the "Tool of the Day" today,' said Q107s celebrated radio DJ, John Derringer, after the race.

Interestingly, in a press release on the occasion of the twentieth anniversary of the Toronto Marathon in 2009, the STWM, proudly announced the participation of legends of the marathon racing world Fauja and Ed. 'Not just the Scotia Toronto Waterfront Marathon but marathoning in Canada as a whole owes a lot to Ed and Fauja,' said race director Alan Brookes. 'Today, STWM is arguably the most exciting marathon in Canada with an IAAF Silver Label and global recognition. But it began with Ed and Fauja. In the US, the UK, Germany, Japan, Korea, France, there is a mystique about "the marathon". It's become the life achievement of the everyday person in our era. That certainly has not been the case in Canada, where we've focused more on participation, doing a 10K or maybe a half marathon. But Ed and Fauja are about excellence. About the pursuit of excellence regardless of age or other perceived limitations. "Don't underestimate yourself," is Ed's message. YOU can do a marathon, and put it on your list of the Top 10 Things you have to do in your life. Don't be the Tool of the Day! That's the spirit of our event, and we're proud that Ed and Fauja have infused STWM with this.' The STWM that owes its growth to Fauja and Ed is supposed to have attracted 20,000 participants, as opposed to only 935 in 2003.

11

SIKH POSTER BOY

The calendar was still clinging on to its 2003 timeline. Rather the date was only six weeks apart from the day Fauja had set a new world record. But this date was somehow more important than all the other dates. It had been two years since 9/11 had taken place, but Sikhs were still being killed and attacked in America. They were being confused with the Arabs because of the turban, which many Americans referred to as 'dirty curtains'.

It may be mentioned that the turban an outward symbol of the religion, is mandated in Sikhism, which interestingly has been a hindrance and a help when interacting with the outside. Founded by Guru Nanak (1469-1539) and propagated by nine other successors from 1491-1708, Sikhism has grown to become the fifth largest religion of the world. The faith assumed martial characteristics after Guru Gobind Singh, the 10th Guru, took cudgels against tyranny and baptised its followers to create a fierce race for the cause. His followers, called 'Singhs', or Lions, were required to keep unshorn hair, possess a sword and a comb, and wear a steel bangle and short breeches at all times. The 10th Guru, besides defining

physical attire, also made significant changes in the functioning of the religion. Dissolving the system of succession, he conferred the title of Guruship to a book of spiritual teachings of the Gurus and other saints of that time and referred to it as *Sri Guru Granth Sahib*. The *Sri Guru Granth Sahib*, which contains teachings of six gurus and twenty-eight saints, ever since has been the source of truth, guidance, and inspiration for the twenty-five million odd Sikhs across the world.

The New York Marathon was in a way being viewed as a watershed by the Sikhs in changing mindsets of New Yorkers, as Fauja chanted his prayers at the start line. From the very onset, he knew it was going to be a tough marathon. A third full marathon within a span of six months and the second one in less than two months was not something that doctors would prescribe. But then he never took what they prescribed as his agenda was clear. The Sikh image had to be enhanced, so what if he was indisposed on that day. He was ready to risk his life. 'Nothing happens without taking risk,' said Fauja.

The race almost became Fauja's Waterloo, as he struggled to run the marathon. However, despite deteriorating health with each passing milestone, Fauja refused to pull out as he felt the turban made him more accountable of his deeds than the rest. If his running the race could enhance the Sikh image, his pulling out could undermine it also. So he thought. Two professors, Nathaniel D. Paxson and James Buchanan, Fellows at George Mason University, Department of Economics in a study entitled *The Entrepreneurial Ethic of the Sikhs: Religious Signalling and the Importance of Social Capital for Trust*, state that the tenth guru of the Sikhs designed an institution of *bana* (wearing clearly identifiable clothes and the

outward display of religious affiliation symbols in public) for the very reason that it forces Sikhs to be more accountable to others. How very true in Fauja's case!

Fauja, describing his harrowing New York experience in choicest Punjabi abuses explained at length his agony on the track. 'I was down with flu, my ankle was aching, and I was badly jet-lagged with so many flights in the last few weeks. Nothing was going right for me.' More Punjabi expletives followed as the tale got horrid. Pain-relieving sprays had to be administered twice to Fauja's ankle on the course as photographers converted his discomfort into a photo opportunity. As if this was not enough, a few white supremacists from the crowd jeered, 'Hey, Osama Bin Laden' and 'Look at Saddam', along the 26-mile route. A resilient Fauja, in spite of all odds, completed the race but it was to be the toughest race of his life. It took him over seven hours to cover the distance which he had run in less than six hours a few weeks ago. And as he took off his T-shirt at the end of the race to allow fresh air to act as balm to his tired body, he collapsed, sending everyone into a tizzy that it might be the end of an era. The coach immediately threw his coat on Fauja, who was then rushed to the standing ambulance where he was administered first aid.

However, on regaining composure, his first reaction was to get out of the ambulance as quickly as possible as he realised he was being taken to a hospital amidst media glare, a sight which he was not proud of. Photographers and media crews were crowding to click him for their next day's news story and Fauja was embarrassed. 'I could not digest the fact I was being clicked since I was in my turban, symbol of Sikh pride. Nothing is wrong with me, take me away,' ordered Fauja to the folks around. Youngsters, who

understood his plight, quickly got a car and tumbled him in and zoomed away.

The Sikh community euphorically celebrated Fauja's achievement, showering him with a lot of accolades. To commemorate his achievement, he was awarded the prestigious Ellis Island Peace Award, the first time it was given to a non-American. Apart from congressional awards, the Ellis Island Medals of Honour are the only awards recognised by Congress. They are given annually by the National Ethnic Coalition of Organisations (NECO) to Americans of all ethnic, cultural and religious origins for their personal and professional achievements and contributions. William Fugazy, NECO Founder and Vice chair in a quote said – 'Singh is a symbol of racial tolerance, and his run helps bridge the gap caused by the September 11 terrorist attacks.'

However, in spite of the award, the trauma and difference in timing scarred Fauja's confidence totally and he started retreating into a shell. His emerging stoop and the missing laughter clearly indicated that he was disillusioned with himself and convinced that this could well have been his last race. This state of mind was unlike Fauja and Harmander his coach was clearly worried. He started spending quality time with Fauja and counselled the great Fauja to overcome his mental negativity. As a coach, he realised it was important that his student kept up with his training and run a marathon again. It was for the sake of Fauja's longevity.

The next London marathon was to be held in April 2004, and by the time Sikh New Year approached (13 April), Fauja, was ready to test himself again. It was a make or break marathon for Fauja. Like mentioned previously, it seemed that God had his own plans for Fauja: the 93-year-old runner, in a sheer super-human effort

reduced his time by more than an hour and finished the race in 6 hours 7 minutes. He was ready to take on the world again. However, coach Harmander had different ideas. It was a hard decision, but Harmander asked Fauja to hang his running shoes for full marathons. 'No more marathons,' said the coach. He was eyeing something bigger. He wanted Fauja to store all his energy to run a marathon at 99 which would make him the oldest marathon runner of the world. Six years were left before Fauja could have a go at the Greek's[1] record of running a marathon. Besides the concern that would Fauja live to be 99, the other was to engage Fauja in a training regime that would endure him to become a human marvel.

12

CATCH-22

Fauja was 93 years old now. He had reached a point in life where both scenarios – running or hanging up of his shoes – could prove fatal. Too much running could be lethal was an opinion that many medicos shared, but total withdrawal could also lead to drastic effects. Since Fauja by now had developed an active lifestyle, many feared that anything less than that could be detrimental to his health. 'I can either walk or sleep. The moment I am idle, I will die,' are Fauja's own words, indicative of his running addiction. Fame and attention were the other aspects which gave Fauja that adrenaline rush, which many psychologists say is one of the strong causes of longevity.

In fact, Fauja had by now started enjoying every moment of his fame. Be it the blondes calling out 'grand-dad', or the cheers he got from the young and old who stood along the course hooting for him, Fauja enjoyed every moment. A right balance had to be maintained if Fauja had to withdraw from active running. Bearing this in mind and that the ultimate goal was to keep Fauja healthy and kicking for the big run, his coach launched a selective running

programe to keep Fauja engaged. In 2004, the then chief minister of Punjab, Capt. Amarinder Singh, in a personal letter invited Fauja Singh to participate in a state-sponsored marathon to commemorate the 300th Anniversary of Martyrdom of the 10th Sikh Guru, Guru Gobind Singh's sons. Called *Sahibzadas*, his four sons, Ajit Singh, Jujhar Singh, Zorawar Singh and Fateh Singh, following family tradition, had attained martyrdom while fighting the excesses of the Mughal ruler Aurangzeb. In his note Amarinder Singh wrote:

> *Dear Fauja Singh Ji, as the most prominent veteran Sikh marathon runner in the world today, no marathon event can be complete without your participation. Your participation will not only make it a world event and attract people from all parts of the world but also an inspiration to the youth and help to promote the culture of physical fitness.*

Fauja, in spite of ill health and against the advice of his coach, had immediately sent his assent to the chief minister's request, as it was the first time his home country was recognising him. He had always thought that if he had tried running marathons back home, his village would have termed him mad. Being invited to run for a cause for his home state was a big event in his life. Fauja ran in the inaugural Sahibzada marathon (he ran for 10 kms of the full distance) on 24 December 2004, from Chamkaur Sahib to Fatehgarh Sahib. 'I left India 13 years ago and have always missed my country. When I got an invitation, I was not well; but as the event was associated with the 300th anniversary of martyrdom of Sahibzadas, I could not stop myself,' said Fauja Singh in a media interview to *The Tribune*, after the race. The chief minister had personally received Fauja Singh at the stadium.

The following year in 2005, Fauja's coach set up an athletic event for Fauja that was to become part of Britain's Sikhs contribution to back London's bid for the 2012 Olympics. The event attracted huge crowd and turned out to be a record-breaking occasion. Held at Mile End Park Stadium, East London, on a Saturday, 2 July 2005 the coach set up an eight in one race for the 94-year-old ex-farmer and gave him a time limit to complete it in 94 minutes. Fauja was entrusted with a task to run six races covering eight distances – 100m, 200m, and 400m, the mile, 1500m, 3000m and 5000m – in a time limit of 94 minutes where he would be measured for world records in his age bracket.

Bridget Cushnan, Secretary, British Masters Athletics Federation wrote in his event report titled – '94-year-old breaks 5 records within 94 minutes':

As part of their contribution to the Back the Bid (for London 2012 Olympics) campaign, the Sikh Community hosted a record-breaking event at Mile End Park Stadium, East London, on Saturday, 2 July. Star performer was the indefatigable 94-year-old Fauja Singh. His aim was to run 100m, 200m, and 400m, the mile and 1500m, and a 3000m continuing on to finish the 5000m. Six races covering eight distances in a time limit of 94 minutes. Impossible? Nothing is impossible for the ex-farmer from the Punjab! Together with his enthusiastic coach, Harmander Singh, who himself had just missed out on the qualifying time for 10,000m at the 1980 Moscow Olympics, and a group of training partners, Fauja clocked 19.97 seconds (hand timed) for the 100m, missing the UK record by 7/100th of a second. In the 200m he obliterated the UK M90 age

group 200m clocking an amazing 45.13 sec. The 400m he covered in 1.49.28 sec, to become the first in Briton ever to contest this distance. The UK 800m time he beat by 18.02 sec, running 4.20.97 sec.

The magic mile he ran in 9.40.13, timed at 9.03.37 for 1500m in the process. The last event, the 5000m, 12½ times round the track, seemed a daunting target.

Cheered on by the mayor, local and international press and supporters, he reeled off consistent laps, setting a new UK M90 3000m in 18.38.48 and continuing to complete 5000m in 31.31.12, just 5.67 sec off the current UK record.

With five records, or six, if you allow for the fact that all races plus recovery time were completed within the 94 minutes, Fauja still had enough puff to conduct media interviews!

'Dusso ki puchna hai' (ask whatever you want to?), he is supposed to have asked the English media in chaste Punjabi. Fauja always insisted that he be asked direct questions for interviews as he did not like the idea of giving lectures.

Once this event was out of the way Fauja's focus mostly remained towards half marathons and the symbolic ones where he was requested to lend his name to raise charity or to add glamour and credence to the event.

As his fame spread across continents and countries, he also got an invite from the then President of Pakistan, Pervez Musharraf to participate in the inaugural Lahore Marathon.

Considering this invite also as a matter of great pride, Fauja acknowledged Musharraf's invitation with 'Yes'. For him it was a

big day – an Indian born-Briton running through the streets of Lahore, showcasing the rich mutual culture and heritage of pre-Partition India. Fauja was accompanied in the marathon by his running partners from Britain, Ajit Singh, Amrik Singh and his coach Harmander. In Lahore, Fauja and his friends ran in the 10km race where Fauja set a new record again by clocking 64 minutes for the distance; thereby breaking his previous best of 68 minutes which he had set in the Hyde Park Capital Radio Help a London Child Race.

Fauja's presence was also to bolster a national movement for improving fitness standards in Pakistan, one of the reasons cited by the Pakistani authorities in the invite. So overwhelming was his presence that a Pakistani woman actually proposed Fauja for marriage which he, in his humorous style, politely turned down by saying there was no father-in-law available for *milni* (a Sikh wedding tradition whereby the girl's father and the boy's father hug each other)!

Fauja's popularity now had reached Buckingham Palace. Fame that should have started dwindling after Fauja had stopped running full marathons, for some strange reason kept following him.

'*Kaka Rani ney doe vaari haath milaan layi bulaya* (The Queen has called me twice to shake hands with me). The first time he was invited by Her Majesty the Queen was in 2004 for Christmas dinner at Buckingham Palace. She later awarded him with the runner-up award of Living Legend at Windsor Castle in 2006.

Life paced along well with no major health hiccups and Fauja kept making appearances at various racing and associated events which included two trips to Kericho in Kenya, courtesy of

Guru Nanak Nishkam Sewak Jatha, which has its headquarters in Birmingham; the Athens Olympics Torch Bearer; opening of a new school Gym in London Borough of Newham; numerous celebrity dinners by a range of high society groups; and more recently in addition to the London 2012 Olympics promotion races, Fauja ran with the Queen Elizabeth's Commonwealth Games Baton Relay for the Delhi Games as well.

It was the May of 2010 now and Fauja had turned 99 in April. Time had arrived for Fauja to take up the challenge to become the oldest marathon runner in the world. Was Fauja up to it was the question everyone was asking? All eyes in the running world were on him. All he needed was to walk the distance to become the world's oldest marathon man.

However, there was something that was disturbing Fauja. If his son's death became a reason for him to run, his inability to win over his granddaughter's custody from her maternal grandparents was slowly killing him from inside. 'I will not die of ill health but depression due to this,' remarked Fauja, sharing his love for his granddaughter. 'I have always warned my children not to discuss family politics in front of me,' said Fauja, explaining how severely family politics affected him.

However, amidst all this chaos Fauja was aware of the promise he had made to himself, which was to run a marathon at 99. His coach had already enrolled his name for the Luxembourg Inter-Faith Marathon which was to be witnessed by His Holiness the Dalai Lama. Press releases[1] announcing Fauja's participation and the possibility of a new record being set by him had been dispatched far and wide by the organisers.

However, there were a lot of apprehensions/hindrances that Fauja felt could come in the way of this marathon. For one, Fauja had no escape route in spite of the fact that he had not been practising with the same gusto as he used to when he was running full marathons.

Secondly, to add to his woes his coach Harmander decided not to run alongside just in case someone raised a frivolous objection. The man selected to run along was Nirmal Singh Lotay (deputy coach), who would ensure that the 99-year-old remained well throughout the route. The coach also allowed Fauja to be entered only for the half marathon since the full marathon course would become challenging for Fauja in the last six miles.

The other factor that irked Fauja was the timing of the race. He liked to run in races that started early in the day. Running in the morning was more like a cakewalk for Fauja as compared to the ones that started in the evening as he felt the day's tiredness could hamper his running.

But in spite of all these adversities, he ran. Fauja successfully established himself as the oldest half marathon runner of the world. No other man at the age of 99 had run a distance of 13.1 miles or a half marathon. In spite of all the oddities that had clubbed together to pull down the great Fauja, human courage had triumphed and a new frontier had been achieved. So what if the timing was not to the runner's liking. He achieved the target in 3 hours 33 minutes, much longer than his usual wrap up time.

'I promise I will run a full marathon at 100,' said Fauja not satisfied with being called the oldest half marathon runner.

The sequence of Fauja Singh's half and full marathon events included:

London Flora Marathon 2000: 6 hours 54 minutes
London Flora Marathon 2001: 6 hours 54 Minutes
London Flora Marathon 2002: 6 hours 45 Minutes
Bupa Great North Run (Half Marathon) 2002: 2 hours 39 minutes

London Flora Marathon 2003: 6 hours 2 minutes
Toronto Waterfront Marathon 2003: 5 hours 40 minutes
New York City Marathon 2003: 7 hours 35 minutes
London Flora Marathon 2004: 6 hours 7 minutes
Glasgow City Half Marathon 2004: 2 hours 33 minutes
Capital Radio Help a London Child 10,000m 2004: 68 minutes

Toronto Waterfront Half Marathon 2004: 2 hours 29 minutes 59 seconds

Lahore Marathon (10,000m) 2005: 64 minutes
Luxembourg Marathon (Half Marathon) 2010: 3 hours 33 minutes.

13

THE COACH

'If it was not for my coach, I would have been nothing. After Wahe Guru, I owe my life to my mentor and coach Harmander Singh.'

Fauja Singh describes his coach Harmander Singh thus. Ever since their first meeting, Harmander Singh has not only remained Fauja's coach, but mentor and guardian too, protecting Fauja from all quarters.

The first time the duo came in contact was in October 1999, when Fauja had shown a willingness to run a marathon after watching it on TV.

Singapore born Sikh-Briton, Harmander Singh, who lives in Ilford, Essex, was born in an orthodox Sikh family in 1959. The family originally hails from Ferozepur district in Punjab, but his father had reached Singapore as part of the Royal Engineers. A keen athlete since childhood, Harmander developed running as a passion when academics and he stopped getting along! Though not the type one would immediately identify with long distance running, given his mediocre physique, but the fact of the matter

is that he narrowly missed selection in the Moscow Olympics as part of the England team.

His innings with running started after his Physical Training (PT) teacher in school asked him to put his energy to good use since he always seemed to be running into trouble with his teachers! Incidentally, the physical teacher was none other than John Sailsbury, the athlete who ran alongside Running Sikh Milkha Singh in the Tokyo Commonwealth Games.

As for his other characteristics, he is wheatish in complexion, supports a stubble-like beard and would find himself low down the rank if he enrolled in a turban tying competition. He can endlessly talk for hours into your dictaphone, as if it were a marathon, but can be very cheeky with his responses and replies, a feature in his personality that constantly got him into trouble with his teachers.

A veteran of many marathons, he still does not own a car as he either jogs or uses the public transport to reach his desired destination. He is a public servant by profession, dealing with social policy. And, most importantly he is the only source of information on Fauja.

Fauja, the man he is, has no clue about his running career as anything and everything is *paroo* (Punjabi word for before) for him. The BBC, having written innumerable articles on Fauja Singh, would be disappointed to know that this protagonist of many stories has no recall of its brand name and calls it the company whose loudspeaker trumpets the world over.

Harmander Singh was introduced to Fauja by the local Sikh community who wanted him to assist Fauja to gain entry into the London Marathon and later train him, as mentioned in the earlier chapters.

After the introductions had been made, Harmander posed a few questions to Fauja (then 88 years old) as to why he wanted to run and was he ready to undergo the rigorous training.

Harmander, to test Fauja's determination, categorically told his to-be student that only mad people run a marathon, a tag line which Fauja uses frequently for media interviews.

Once Harmander had assessed the man's determination, he was ready to work with him. Incidentally, Harmander has also trained Buster Martin, who claims to be 104-year-old and hence the oldest in the running business. However, Martin's age is in dispute as he has not been able to produce any document to corroborate his claim. This effectively makes Fauja the oldest half marathon runner on the scene, his British passport a proof of his age.

'The way I work is that I always try to inspire people to be the best in anything they want to do. In my profession, which effectively is public service, there are some people who would find all the reasons why you can't do it. Others like me will suggest this is how you can do it,' said Harmander when asked for his first impression of Fauja when they met.

'Also, I am not a coach in the traditional sense, since I only suggest. I always run with the individuals, explain various things to them from my experience and make them judge what is best for them.' A physics student and an engineer by education, Harmander applied various theories, like how to conserve energy or how to use it when required.

Sharing a few basic tips on training (a detailed regime is given in Appendix 2), Harmander has the following do's and don'ts for marathon runners:

- Before anything, make sure you do a good warm up, and when you finish the training session, end with a warm down.
- Listen to your own body. It means do not alter your speed according to the other participants. All body types are different.
- Relax, because in stiffness, you will lose energy.
- Keep drinking water. Even if you don't want to drink, take a sip. You don't want to go dry, because it is harder to recover from dehydration.
- Do not stop taking steps. If you can't run, start walking. Fauja would say *Kade taan mukugi* (It will end sometime).
- Don't look up while running. Look five to six feet ahead.

It's a separate matter that Fauja, when running a race, chooses to ignore all advice and plays to the gallery. Recalling a humorous incident: Harmander, who was running along with Fauja had suddenly felt the urge to use the loo. Harmander went looking for a loo and told Fauja to run slowly so that he could catch up. Cheered by the crowd on that particular lap, Fauja forgot to slow down and instead increased his speed. Harmander had to huff and puff his way to catch up with the old man.

After overcoming the challenge of getting Fauja an entry into the 2000 London Flora Marathon (the struggle has been discussed in the previous chapters), Harmander had never imagined that his first step with the 88-year-old would go so far. Steps soon turned into strides, as Harmander jogged alongside Fauja with a water bottle in his hand while training Fauja for the big event.

But everything was not as smooth as perceived. Language came in as a big barrier between the two. Though both came from the

same state and religion, their difference in upbringing became a barrier. Since Harmander could coach only on weekends, he was keen to leave written instructions during the week for Fauja to follow. But Fauja could not read.

Fauja, a hardcore Punjabi, could manage to read a few lines in Punjabi, while the coach could not write in Punjabi. Luckily for the coach, Fauja had a reasonably good memory and could recall every instruction.

Strides soon advanced into a marathon and Harmander was elated the day Fauja successfully completed his first marathon (April 2000). As Fauja clocked mile after mile, along with it came fame, glory, criticism and all those challenges which come when an ordinary old age pensioner metamorphoses into a celebrity.

Soon the growing popularity of the protagonist started bearing a positive impact on the life of the coach as well. Harmander soon found himself playing an additional role – that of mentor, media advisor, security man, event manager, escort, counsellor, clerk, etc. So involved was the coach that there was a point when his family life slid to the second position.

Fauja Singh, according to his coach, is a simpleton and a very honest man. He goes everywhere his community invites him and donates every penny he raises. Sadly, at times Harmandar feels that the community just wants to use him to its benefit without understanding the ill effects these random invites have on Fauja's health and training.

He recollects an instance when Fauja fell unwell at the end of the New York Marathon. All the Punjabis who had gathered to see him just wanted to get a picture clicked with Fauja. No one seemed worried about his condition or thought of administering him first aid.

I am so pleased to know that you are celebrating your one hundredth birthday on 1st April, 2011. I send my congratulations and best wishes to you on such a special occasion.

Elizabeth R

Mr. Fauja Singh

A telegram from her Majesty, the Queen congratulating Fauja Singh on his 100th birthday.

Fauja Singh's 100th birhtday cake at Nishkam Centre (02.04.2011)

At the Fauja Singh's Charity Fun Run; Valentines Park, Ilford, UK

Fauja Singh with little Amarpreet Singh Bahra

Sikh Relay Marathon Team at the 2007 Marathon

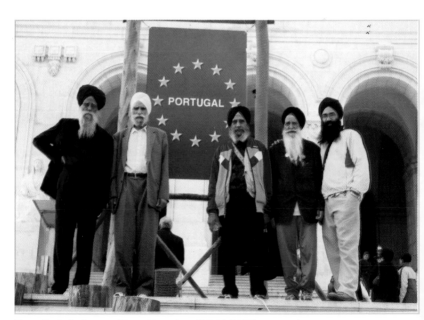

Team Fauja in Portugal for a Marathon (25-03.2006)

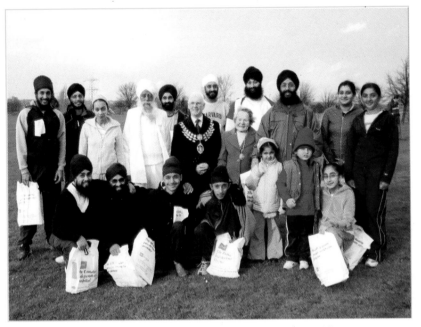

Fauja Singh with Mayor and Mayoress of Redbridge at Fauja Singh's Charity Run; Redbridge, UK

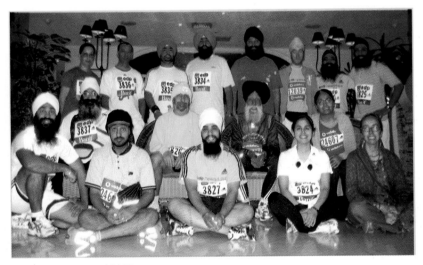

Team Fauja, Portugal 2007

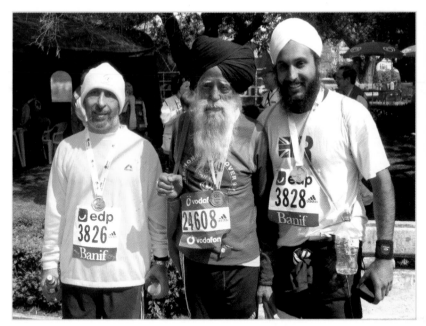

Lisbon 2007. *Left to Right*: Fauja Singh's coach Harmander Singh,
Fauja Singh, Himmat Singh

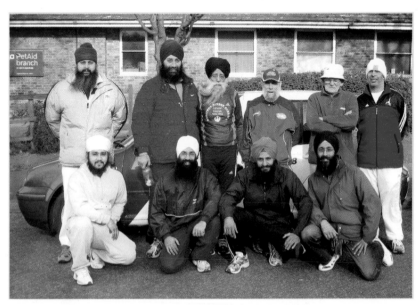

Fauja Singh and his 'running' friends; Redbridge, UK (03-02-2008)

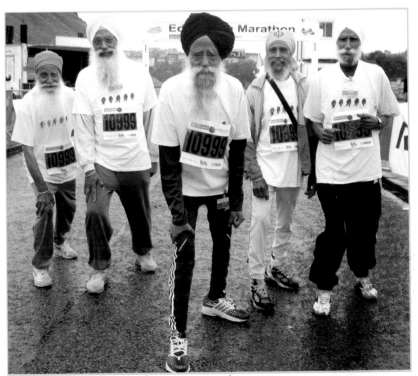

Fauja Singh with fellow Marathoners from the group, Sikhs in City, at a Marathon in Edinburgh. [photo credtit@ Edinburgh Marathon, Race Director, Damien O'Looney]

Fauja Singh being interviewed by Channel Punjab at the 2007 Sikh Relay Marathon

Fauja Singh and (Late) Harbhajan Singh Sambi at Simba Union (07.12.2007)

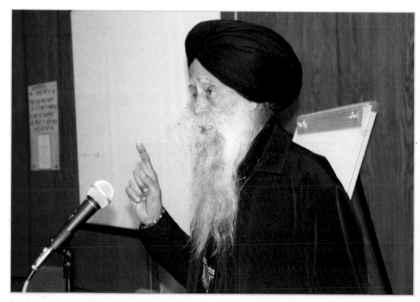

Fauja Singh at Nishkam Saint Puran Singh Institute, Kericho, Kenya (09.12.2004)

Fauja Singh at Simba Union, Nairobi

Left to Right: Bhai Sahib Bhai (Dr) Mohinder Singh, Fauja Singh, Dr Kulraj Singh

Fauja Singh with his wife, Gian Kaur

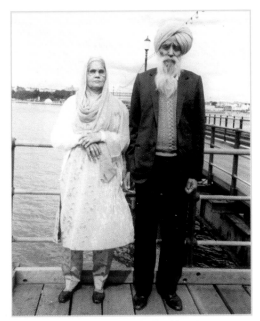

Fauja Singh with his wife, Gian Kaur

Fauja Singh in his village, Bias Pind

Fauja Singh in his native village, Bias Pind. He is seen blessing the players who had gathered for a football tournament (February 2010)

With one of his great grand daughters in the village

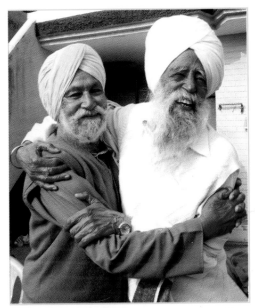

Hugging an old associate, Bakhshish Singh in his native village, Bias Pind

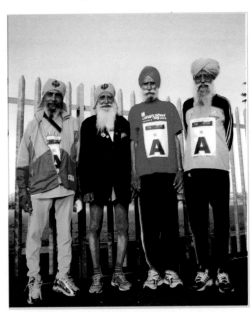

Oldest Sikh Relay Marathon Team at the 2007 Marathon. *Left to Right*:
Amreek Singh, Ajit Singh, Kurnal Singh, Fauja Singh

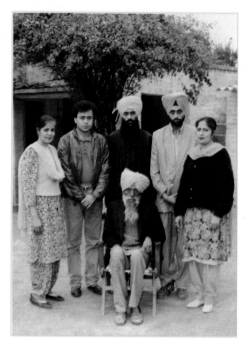

Fauja Singh with his children

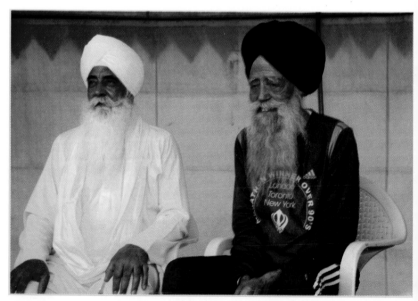

Fauja Singh and Bhai Singh Bhai (Dr) Mohinder Singh at Simba Union, Nairobi, Kenya

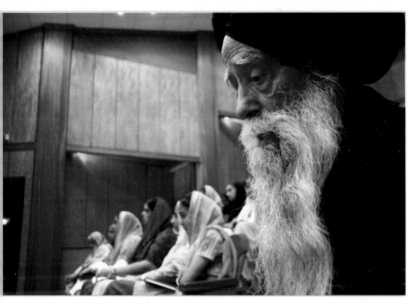

Fauja Singh at Nishkam saint Puran Singh Institute, Kericho, Kenya (09.12.2004)

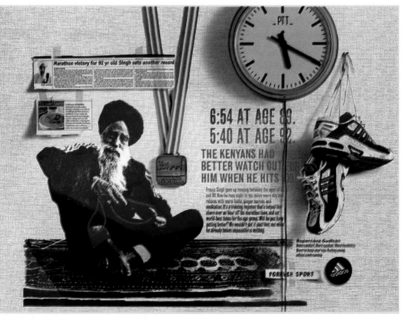

The Adidas advertisement featuring Fauja Singh

Team Fauja in Lisbon (25.03.2006)

'I, as a coach, had to put my foot down and ask people to move out of his way,' said Harmander, who has encountered many such occasions where he had to literally protect Fauja. 'They want to use him but do not want to help him. I can assure you, his career would have been richer and more meaningful to society had the Sikh community supported him. They often promise but never deliver,' feels the coach who is very vocal and upset about this.

Harmander has had to sternly remind Fauja many a time not to waste time attending weddings, social functions and inaugurating sports tournaments, but instead concentrate on his training. For each time Fauja has slackened even a little in his running time, he has become disillusioned and depressed, which is not good for his well-being.

'Fauja, like all runners, is a product with a limited shelf life for society,' says Harmander. 'Having looked at his stature and what he has achieved, I wanted to market him in as many fields as possible. But at the same time, I want to preserve his shelf life a bit longer also; this is the main reason that I had asked Fauja to quit running full marathons.'

But somehow Harmander's suggestion did not augur well with the community and armchair experts started accusing him of controlling Fauja's life.

'My only interest was to preserve the athlete's life in a healthy way. Most top athletes peak for four or five years and it had already been six for Fauja. He needed rest if he wanted to attempt the record of being the oldest marathon runner when he turned 99.'

It is more than eleven years that Harmander has been associated with Fauja and, he has not only been keeping a watch on Fauja's

physical ability but has also kept a tab on his mental framework constantly.

As a coach, his attempt has always been to nurture Fauja to achieve certain things for himself and the community. Contrary to the view held by certain segments that he has used Fauja to enhance his own profile, Harmander has selflessly worked for Fauja's well-being. He has been working like his personal secretary, handling all of Fauja's running affairs, and is the face for Fauja in the international media, since the runner cannot speak in English. He not only translates Fauja's words for the press but at times has had to embellish his statements as well. He is basically the athlete's link not only to the running world but the external one also.

His commitment to Fauja can be judged from the fact that Harmander chose to be with his disciple in New York for the marathon, even as his son battled for his life on a ventilator, fighting a rare disease – Churgg-Strauss syndrome.

Harmander felt his commitment to his faith was more important than sitting next to his son as it would not have helped in any way; whereas his presence in New York was very important. And Fauja says, 'People keep asking me that how did I come to know of Harmander, and my reply is, the same way that I know you.'

Harmander also has the unique distinction of motivating a group of elder Sikh men to run marathons and has created a group by the name – Sikhs in the City – a take from Hollywood movie *Sex and the City*. The group, which originally comprised six Sikhs who shared a combined age of 336 in 2009, are known faces on the marathon scene. It comprised of Fauja Singh (98), Ajit Singh (79), Amrik Singh (79), Karnail Singh (80), another Ajit Singh (80) and Gurbaksh Singh (79). Sadly, the older Ajit Singh has passed

away and the group has been reduced to a fivesome, but it has left an indelible mark on the running world.

Presently, Harmander Singh is monitoring Fauja with a view to decide whether Fauja will be able to run a full marathon again. According to him Fauja's recent times for even short distances were getting slower than what he would have ideally liked. For example, at Luxembourg, where Fauja ran a half marathon and became the oldest marathon runner, his time had reduced drastically, said a concerned Harmander.

'I have just been a facilitator. If Fauja didn't get out of his bed and not come out running I wouldn't have been able to do anything. I just feel honoured to be associated with him. A great man indeed.'

14

DIET

Punjabis are known gourmets by nature. But Fauja is different.

One of the reasons for Fauja's blessed health and longevity is that he is just the opposite of his counterparts when it comes to food habits. At 5 feet 8 inches, he weighs just 53 kilos. His bone density is of a 40-year-old and a relaxing heart rate of 52 beats per minute. His mantra is 'Eat to live', as opposed to the theory, 'Live to eat', which many Punjabis propound as key to a good life, especially when they are digging into butter chicken tikka masala.

'*Meri zindagi parhez di hai. Dunger vangur eh mulkan which jina marji kahi jao,* (My life is protected because I control my eating. Like an animal, you can eat as much as you like in these rich countries),' says Fauja, attributing his longevity to his eating habits.

The habits apparently are a result of being told by a doctor that life was not only about taste. Surprisingly, as should be the normal course for any athlete, Fauja's daily diet is not based on any nutritionist's plan. Observing him eat, it can be concluded that

he is not a dietician's poster boy as his diet is based on the chart 'doctor' Fauja Singh has prepared for himself. He has no clue what proteins, carbohydrates, fats, starches and vitamins mean and sticks to his own logic where food is concerned.

Ishi Khosla, a known Delhi based clinical nutritionist commenting on Fauja's dietary habits had this to say. According to researchers, restricted calorie intake along with nutrient density and physical activity not only helps lose weight, improve energy levels but also increases lifespan. Calorie restriction is related to anti-ageing process as it reduces metabolic rate, oxidative damage and improves markers of age-related diseases including diabetes such as insulin resistance. All this explains beautifully, Fauja Singh's state of fitness and good health. However, there is always room for improvement.

Fauja can be a very fussy eater in the house, even to the point of creating a scene. According to his son Sukhjinder, the household has adapted to his father's eating habits since he can be very finicky with what he wants to eat and not eat. For example, Fauja detests cauliflower. As per *Faujanomics*, it causes some sort of bile or 'bye' in his body that makes him uncomfortable. He also refrains from eating ladyfinger and avoids rice. Recommended food as per him is lentils and bitter gourd.

In another example of the amount of fuss he can create over food, Fauja had once created a commotion in America where he had gone with his son Sukhjinder as a distinguished guest to be part of the opening ceremony of the Sikh gallery at the Smithsonian museum in Washington in 2005. He was put up in a hotel and the community had arranged for him to shake hands with the then President George W. Bush. According to Fauja, he hated the

milk in the hotel which made him feel sick. He soon summoned the folks and ordered them to shift him to some Punjabi's house. '*Bush they chakkar wich tussi baba maar lena hai* (In your effort to make me meet Bush, you will kill me).'

He is particularly critical of the way Asians ignore their health. 'Below the torso, almost all forty-year-olds are in poor physical shape in the UK. They (a Punjabi abuse follows), can't even walk a mile,' says Fauja, pointing to a few overweight people coming out of a pub. Health is everything. If you don't have health, you will not be able to cherish life – your wealth, bungalow and big car will become meaningless, feels Fauja. 'I have seen almost the entire world, thanks to my running expeditions. I have met different people including top dignitaries, and seen different hues of life just because of my good health. I wish the same health for everyone,' he says, lamenting the fact that young people are giving away their most precious jewel to erroneous eating habits.

He is also very perturbed over the fact that Punjabi youth are moving away from a healthy lifestyle and taking to drugs. Besides the urge to visit his native village, one of the reasons he goes and contributes money for holding of sport tourneys is to encourage the youth there to adopt a healthy lifestyle.

Talking about food habits, his *Faujanomics* says that more people die of overeating than starvation. 'In Western countries food is rich and tasty and one can eat as much as one wants to. So, seal your lips is his mantra. One, you'll eat less and secondly you'll talk less. Both the things will keep you out of trouble,' says Fauja in his cheeky style.

An early riser, Fauja usually wakes up by 6.30 a.m. and kick starts his day with a cup of Indian style tea or *chaa*.

Chaa is followed by a half bowl of hot crushed *alsi pinni,* (an Indian sweet made of flaxseed, nuts, wholemeal flour and jaggery cooked in rarefied butter). It is Fauja's staple diet and the runner swears by its qualities. Incidentally, after a newspaper in Canada reported that Fauja's secret to health was *alsi pinni* many Indian stores started storing them and advertising them as food for longevity. 'Though you don't get the kind made in India but a lot of Indian and Pakistani stores in East London stores make them,' says Fauja, explaining his morning diet. His *pinni* indulgence is followed by one bowl of homemade yogurt and two glasses of water and then he sets out for the day.

Fauja believes in the prevention of health disorder as it will be very difficult for him to bounce back if he falls ill. A complete vegetarian, food, as per him should neither cause constipation nor should it work as a laxative.

For lunch, which is usually *langar* (community kitchen) in a Sikh temple, he eats the lentil of the day with one chapatti. Lunch is approximately around noon and is followed by another cup of tea.

'I do not indulge in mid-day snacks. *Samosas, tikkis* and fried food are very tough on my digestion.'

Dinner for Fauja is again very light. It usually comprises a vegetable of his choice, garnished heavily in ginger, a bowl of lentil soup and two slices of brown bread. 'My teeth aren't as good as they used to be, so brown bread dipped in lentil soup is easy to chew,' he says, explaining his dinner.

Besides this, Fauja is a fruit lover and vouches that a couple of mangoes after lunch keep him fit and save him from constipation. He does not recommend cantaloupes or melons as they do not augur well with his body.

Fauja, however, makes it clear that this is a routine which he has been following only since the last ten years or so. 'I have eaten and drank almost everything,' he pronounces without any pretensions. 'But it is the sealing of my lips in my later age towards certain food items that has contributed to my longevity,' he says.

15

DAILY ROUTINE

Baby oil companies would be delighted to hear that 99-year-old Fauja Singh, before setting off for the day massages his fragile and weathered body with baby oil. He finds baby oil suits his body and skin the best, which not only has to face a battering because of age, but also the rigour of the runner's daily routine, which starts at 6.30 a.m. during summer. Also, the traditional mustard oil which is mostly used for massage in India does not augur well for his clothes.

Early rising is part of a normal routine for Punjab farmers, especially for those who have to plough their fields with oxen. It was in the interest of both the farmer and the animal that the farmer tended to his farm work before the sun heated up fully.

Once awake, the first thing Fauja does is to look for the switch of his radio next to his bed to play the Punjabi channel. He finds the channel relaxing. After listening to the radio for at least an hour, Fauja slips into his training clothes and heads for Redbridge, usually driven there by his son, where he practises running. Running, however, is no longer an everyday affair now

and is limited to weekends only, but Fauja has found a unique way to train himself and keep in shape.

A shower everyday is a must after which he does some mental maths, i.e. earmark a ten mile route for himself which he would cover by walking during the day, socialising and visiting the Sikh temples in the vicinity for even more socialising. Gymnasiums are boring for him as he feels claustrophobic in them and feels it does not nourish the body and soul together.

It is recommended that you pour enough fuel in the stomach and have the right walking shoes before accepting his invite to spend a day with him.

It is an endless march of about eight hours consisting of crossing various lanes and streets, passing through shopping malls, stopping by Sikh temples and for the occasional 'Sat Sri Akal' should a fan desperately want to stop Fauja and talk to him. The walk is peppered with *Faujaisms*, as he narrates endless tales and tips on life. On one such walk, he cautioned that one must cross the road only from the striped line (zebra crossing). His take is if someone hits you while you are on this line, he will have no choice but to pay you. Other than that, you are on your own.

The first lap usually is about three miles long and the first halt is at the Seven Kings Sikh temple. Gossip kicks off over a cup of tea and after a half an hour break it's time to set off for the next lap. In between he remembers that he has to collect shoes from a cobbler and diverts towards a mall. Once the job is done, he realises that he needs to pay a visit to his travel agent to get the fare for Canada where his daughter stays. Off he sets in the opposite direction. However, during this entire exercise, he is conscious he

has a guest along and keeps asking if his guest wants refreshment. It's more likely for the guest to opt for an energy drink.

Once these chores are completed, it's time to head for another Sikh Temple in Barking where he would partake of *langar*. In between, he will announce that he is an illiterate and manages his way through instinct. *Langar* is another great socialising forum and various issues are discussed, from ticket fares to Punjab politics.

Lunch complete, a walk to digest food is next on the cards. The walk will soon take him to another Gurudwara, this time in Goodmayes. This is a tea break and should you be in the mood for more gossip, there are many willing participants at the Gurudwara who are willing to have a go at it. However, Fauja suggests that you stay away, as no one knows when the discussion might turn into an argument or a fist fight. He quietly sips his tea, cracks a few jokes, calls out to a few youngsters to ask them about their welfare and then sets out for his return journey home; his running shoes having clocked at least 8 miles before he enters his house on Levit Garden.

Once home, he quietly slips into his room and relaxes by turning on the radio. He is not fond of television or watching movies. 'I cannot watch violence, so why watch something that disturbs one's inner peace,' he asks.

Dinner follows and that's the time he interacts with the family before buzzing off in his room. The hum of the radio is what dominates the room for the next couple of hours before it's time to bid goodnight.

16

SHOE FETISH

Before stepping into the shower, Fauja Singh has carefully gone through his wardrobe to select his clothing of the day. For a man who was mostly seen dressed in a soiled short *kurta* and long underwear, his dressing obsession at this ripe age of 99 is a surprise to family and friends.

If he is not training, he usually pulls out a new suit every day, a matching shirt and a tie for his day's journey. A turban is then carefully selected to match with the clothes, after which the shoes are decided. Frequent interaction with the runner has revealed that he has a very strong shoe fetish. His shoe rack in his small room smacks of a wide ranging collection of sports and formal shoes (size 8) of all kinds of shapes and brands: Adidas, Puma, Ralph Lauren, Gucci, Hugo Boss, Tommy Hilfiger, among many others.

Though Adidas was his sponsor at one point of time, Fauja says the shoes with the panther (Puma) inscribed on them are better for running. According to the runner, Hugo Boss shoes were no good since their soles cannot cope up with his walking routine. He cribs at length about their short shelf life, the shoe critic that he is.

In his parlance, the unlaced long toed designer shoe is Gurgabi (traditional Punjabi shoe) which he likes to wear with his *kurta-pyjama* when he is attending important Punjabi social functions.

Interestingly, he wears sports shoes with his three piece suit, since that is the dress code for his daily routine.

However, the most striking feature of Fauja's collection of sports shoes is the manner in which his name is inscribed on some of them. The right shoe has Fauja written on it and the left has Singh.

For a man who lives off an old age pension, buying expensive shoes can be a task. But this is one of the only extravagances Fauja indulges in vehemently. He has kept his other needs very basic, so most of his pocket money is spent on fashion, an obsession his son in India cribs about. According to Harvinder, his father's fashion mania leaves him worried since crime has risen in Punjab. The new Fauja is famous for his loud dressing sense, one which is associated with Non-Resident Indians especially, the ones who left India penniless. The bright coloured suit, white shoes, gold rings on both hands and a flashy gold watch is fodder for petty criminals. 'He is old and fragile and someone can just shove him around to rob him off the gold,' says Harvinder concerned about the way Fauja keeps roaming around freely in the village to meet people when he is visiting India. 'I have told him many times to dress modestly in the village, but he doesn't bother,' rues his son.

A close look at the runner's neckties in the wardrobe reveal how well-entrenched is his passion for running and sports. Most of his ties have runners images printed on them, denoting the

constant high the man lives in. In Punjab, such a high is referred to as *chardi kalan* (on top of the world).

The spectacle changes the moment Fauja has to participate in a race. Watched by thousands of people, Fauja loves to play to the gallery while running on the track.

Yellow is his favourite colour, as besides being bright, it is associated with being the colour of the Sikh community. When he runs, the yellow adds the extra dimension to his already tall status.

A yellow slip-on over a sweat shirt with Adidas and BLISS imprinted on it is the runner's favourite. He wears this slip-on for almost all the big events. Blue is the favoured colour for track pants as blue also denotes a strong affinity with traditional Sikh dressing.

A yellow turban is then wrapped around the head, a steel *khanda* (Sikh insignia with three different items in it) is pinned on the forehead on the turban and Fauja is all set.

To see Fauja run a marathon in his full attire is euphoric. Many spectators say it gives them the feeling that God himself has descended on the track in Fauja's guise. People from all hues of life cheer him the hilt, celebrating the triumph of the human will.

The frail figure in yellow and blue with a flowing beard, emerging from the streets of London, with determination writ large on his face is perhaps God's advertisement to the world that age is never a barrier to sport. So, whatever be your age get out of your bed, and devote some time to exercise.

17

HUMAN MARVEL

Kimberly Bogin is a marathon examiner in America. Intrigued by Fauja's achievements, she typed Fauja Singh's time into an age grade calculator on www.runners.com, a premier website on running.

She was shocked out of her wits when the score flashed on her screen. The machine had calculated an incredible 128. 78 – an unheard of figure in the running world.

What it literally meant was that Fauja's amazing time would be the equivalent of a young elite runner doing a half marathon in 45:59, a feat that has never been accomplished. The world record in the half marathon is currently 58:23.

This is just one such experiment that has been conducted on the man whom the world has started considering a marvel. The world is inquisitive as to what makes the man tick. It is captivated by the magic steps of the 5 feet 8 inch tall Sikh, and as a result keeps computing and conducting mathematical and medical experiments to understand the enigma that Fauja is.

Fauja, on his part, however, cannot fathom the relevance of these tests. He just knows how to run.

One test on Fauja at the age of 93 revealed that compared to an average person, Fauja's general fitness is 180 per cent higher than average for someone of his age.

But there is more to it than that. And it is a big 'But' because of the difference between his left and right legs, reports media. According to a bone density test conducted on Fauja just before he ran his last Flora London marathon his left leg was equivalent to that of a 40-year-old and his right that of 25-year-old. When Fauja was informed of this difference he had remarked, 'I always knew my left leg is weak.'

In yet another test, the BBC in 2010 invited four outstanding elderly people for a scientific test. The four people included: a 63-year-old female endurance athlete who ran 27 marathons in 27 days after pulling a cart weighing 300 pounds and clocking 23,000 miles in about five years; a 71-year-old male hurdler of repute who trains nearly every day; a 77-year-old lady who has a cold bath and swims outdoors irrespective of the weather conditions; and Fauja Singh. The point of the exercise was to determine if the body ages naturally or if age is just in the mind, and whether one can overcome its effects by ignoring it and by continuing a strenuous daily routine.

The four were asked to undergo four health screening tests at Westminster University in London.

The test included:

1. V02 max – It involves being hooked up to an oxygen mask whilst running on a treadmill or cycling on an exercise bike. I should also mention that, if the doctor would prefer

Fauja does not push himself to his maximum, it is also possible for us to extrapolate this data from a gentler run on the treadmill.

2. Fat to lean ratio – This involves sitting inside a specially designed 'bodpod'.

3. Bone density – This involves a simple non-invasive test on the ankle.

4. Aortic stiffness – Another non-invasive test taken from the wrist.

Fauja Singh, true to his personality, ignored suggestions to take it easy on the first test and outperformed all expectations. He apparently drank a glass of mango shake before the tests. Explaining his experience in an interview, Fauja in his indomitable style said that he was asked to step into a machine similar to a *tandoor* (Indian clay oven), apparently an MRI machine! According to him, medicos there had asked him if he was scared of the medical equipment and his reply had been, No. 'All of you are doctors, you have not got me here to kill me,' he is supposed to have told them.

The results were put forward to a team of doctors who were asked to assess the age of the participants without seeing them.

The doctors' view, based on medical results alone were as follows:

- The 63-year-old was said to be 50 years old – out by 13 years.
- The 71-year-old was said to be 45 years old – out by 26 years.
- The 77-year-old was said to be 55 years old – out by 22 years.
- Fauja Singh was said to be 40 years old.

18

CHARITY/ADIDAS

[handwritten margin note: typo 1,200,00 to 1.2 million]

For a man who lives on old age pension, pocketing extra buck was always a welcome benefit. However, Fauja does not think the same. He has always put the cause of the less privileged first, and has donated all his earnings from running to different charities. Though there is no exact record of the amount he has donated, the estimates collected from his coach and family suggest that in his running career spanning over ten years, Fauja has contributed over 1,20,000 pounds to various charities. The major portion of the said amount is said to be earned from the Adidas contract after the sportswear company (Adidas International BV) signed Fauja Singh for their Running 2004 campaign when he was just 93 years! The speculation is that the amount was substantial but below the 1,00,000 pound sterling mark. The contract was signed on 17 November 2003 and it is believed that Adidas, as per the wish of the runner, had sent his contract amount to charities he wanted to help.

The people of London were surprised to find billboards of an old man sporting a turban and a beard, urging them to buy Adidas sportswear. More shocking was the news that the old man

had been part of the same campaign which previously footballer David Beckham was seen promoting with the tagline 'Impossible is Nothing'. As the news spread of Fauja being Adidas's new posterboy, the *London Evening Standard*, in a report published on 30 March 2004 entitled, 'The New face of Adidas, 93', quoted an Adidas spokesman saying 'Fauja is the oldest runner in the race and everytime he runs a marathon, he seems to be getting quicker. That fitted in perfectly with what our campaign is about. He truly is remarkable. Everything we give him, he gives straight to charity.'

The billboard advertisement showed Fauja dressed in his favourite yellow attire. He is seen waving out to his fans, his wave akin to a sort of blessing he is showering on them, while out on the London Flora Marathon. His proverbial yet infectious smile draws attention towards the magnificence of the 93-year-old man's regal approach to life in spite of being a man of meagre means. The billboard also displays a box which has four options 1) 6:41, age 89; 2) 5:40, age 92; 3) 4:59 –Age 94; 4) Impossible is Nothing. The first, second and fourth boxes have been ticked in the advertisement for the simple reason that Fauja has achieved all the three targets, whereas his next target at 94 is to complete the race in 4.59 hours.

A print advertisement soon followed the display on the billboard. It was far more interesting and creative. It showed Fauja sitting with his usual calm smile in a brown tracksuit and a band of rosary beads is in his hands. The message conveyed through the ad was to emphasise God's blessing on him and represent the '*focus, respect, reverence* and *purity of intention in Fauja*'.

The text of the advertisement was more or less a threatening one: asking the Kenyans, who are considered to be the best marathoners, to beware of this man who is reducing his running time as he heads towards the 100th year of his life!

6:54 at age 89.

5:40 at age 92.

The Kenyans better watch out for him when he hits 100.

The news of Fauja becoming the posterboy for Adidas in 2004 had been received with great fervour. But interestingly Fauja, till many years, could not get himself to pronounce the name of 'Adidas' correctly of which he was the posterboy! He always called it the 'Kompany' (as in 'company') that sponsored him. In fact, there is a humorous incident which Fauja fondly remembers that happened during one of the shoots. It is said that Fauja was asked to speak the Adidas's slogan, and, it took around thirty-five retakes for Fauja to get it correctly. Fauja is supposed to have told the production team to make him run a marathon instead of forcing him to repeat the lines in English!

Unfortunately, the contract could not be renewed the following year because of certain personal issues in Fauja's life. It is believed that commitments with Adidas were taking their toll on the family of Fauja as he was dependent on his son to commute regularly for shoots and promotional activities. His son, who owns a store, found it difficult to strike a balance between his own livelihood and Fauja's contract as the money raised was also of no benefit to the family since every penny earned went to charity. The coach could only help him on weekends as he himself was employed.

Fauja has been able to attract funds for charity from not just Adidas but also through social functions, Gurudwara appearances and sport tourneys. As always he never carried the money earned from these events back home and always asked the organisations to donate the money to a particular charity. His favourite charity is and remains BLISS, which has been mentioned earlier as well. In 2004,

BLISS for which Fauja has raised over 6000 pounds over the years and has considerably heightened the charity's profile even nominated him for the UK Charity Awards. Nominating Fauja Singh, Jackie Glazebrook, the Community Events Manager at BLISS, wrote:

> I have been responsible for guiding and supporting Fauja's involvement with BLISS for the last five years when he started running marathons in the 'Gift of Life' team at the age of 89. His trainer, mentor and friend, Harmander Singh helped Fauja choose BLISS as Fauja wanted to fulfil his dream as the 'Oldest running for the Youngest'. I also had the privilege of running most of the way with Fauja in the 2003 London Marathon and finishing with Fauja in this year's London Marathon.

Fauja also donates proceeds from his running to various other charities, like Cancer Research, Age Concern, and British Heart Foundation. When running overseas, he has supported local charities there, for example, when he ran in the inaugural Lahore Marathon, he was offered a Persian rug and $US 5,000 by the then Pakistani President Pervez Musharraf. Fauja accepted the rug, but, in a packed stadium, he declined the money and requested it to be given to the poor.

'I think God has given me a long life so that I can run and raise money for the needy,' says Fauja. 'It is a task that He has given me that I donate every penny I earn. How much does an old man need? One can keep aspiring for the unlimited, but running and donating it to charity gives me a high many riches wouldn't have given,' says Fauja proudly.

19

THE JOURNEY AHEAD

Hundred years and still counting is no ordinary achievement. No wonder any British citizen who achieves this milestone gets a personalised birthday wish from none other than Her Majesty, the Queen.

Having turned 100 on 1 April 2011, Fauja's life will be remembered for the man he is and his journey in which, manifests the intrinsic spirit of life. His journey from the dusty fields of Punjab to running in the streets of London at the age of ninety plus will be remembered not just for his courage, endurance and integrity but most of all, for the *joie de vivre* that exudes with each breath he takes. He will be remembered for the imperishable effect his every step has had on the events he participated in. He will be an epitome of inspiration for generations of runners or for the ones who aspire to run in the future. He will always be fondly remembered by the Sikhs for carrying the Sikh flag and enhancing their image, not only through his running feats, but for many other reasons off the track. Through his achievements, he has shown the world as to how resilient, hardworking and honest

the Sikh community as such is. By donating every penny he earns from running for different charities, he has positioned the Sikhs as a community that has its heart at the right place. Perhaps it is also the combined blessings of so many thankful people that have added years to Fauja's age.

A great grandfather to six and grandfather to 14, Fauja Singh is a doting elder. Doting to the point that, though with age and success, he has been able to overcome his material needs, he happily remains shackled to emotions when it comes to his children, grandchildren and great grandchildren. He candidly says no illness has the potential to kill him, but a sad family tale will be his undoing. The reason Fauja has been unable to concentrate on his fitness lately, which incidentally also became a reason for his being unable to complete the full marathon at Luxembourg Interfaith Marathon, has been his inability to come to terms with the fact that he has not been able to devote much time or attention to one of his grandchildren, the daughter of his late son Kuldip Singh. But these are the things that make the otherwise superhuman Fauja, human.

Everyone will perish one day, but before that, he has a burning desire to run a full marathon run at 100, in spite of the concerns shown by doctors, family and the coach.

Fauja, may you run at 100. This book is a celebration of your Punjabi spirit, even though no amount of words will be able to capture it fully. No wonder you are called Fauja, meaning army in Punjabi.

APPENDIX 1

Quotes

Rahul S. Verghese, Founder and CEO, Running And Living Infotainment Pvt Ltd

Ever since I first read about him in 2004, running the London Marathon, I was in awe of him. I also ran the London Marathon the same year but was unable to get a glimpse of the man, who then at 94 was making history.

When I set up the website www.runningandliving.com to spread information and inspire people to start running in India, Fauja Singh was the first name that came to my mind and I put a snap of his on the home page – 6 years on, the snap continues to occupy the prime place on our website, along with some other information also on him.

Fauja Singh defies the basic obstacle that most people come up with – 'I am too old to run' and that 'Running is bad for the knees'. At our workshops on leadership and teaming, I advise all that 'If you are above 95 then I am not sure about the benefits of running, but if you are any younger, then you have nothing to worry about – look at Fauja Singh!' Now I have to revise that age to 100 years!! 'Long Live Fauja Singh' – who I think does not really know that he is a living inspiration. Our ambitious goal of getting 200 million people to start running turns insignificant when we learn that Fauja Singh preparing for another marathon in London as he crosses 100!

Amazing!! Inspirational!! Humbling!!! That's a bit of what we can say about the great man.

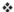

Nina Duttaroy, Writer/Director – *Nothing Is Impossible*. This film on Fauja won the 'Best Short Film Award' at the 2010 New York, Sikh Spinning Wheel Film Festival

I had the privilege of making a film on Fauja Singh in 2009. It was a short portrait of his life and I remember how much the people who funded the film loved the idea, as it would appeal to a broad audience.

One of my enduring memories during the making of the film is of Fauja's love for shoes and his immaculate dress sense, where everything is coloured coordinated from his turban to his shoes. Someone told me that the colour coordination brought him luck and I believe there might be some truth in that, as he has had a charmed life in his older years.

My residing memory of Fauja is of his warmth and humour. Even though we had a language barrier (I cannot speak Punjabi and Fauja speaks no English) his dry humour and charisma were unmistakable. His sheer zest for life was infectious and all members of the crew remarked on how much younger he looked and acted than his age.

There is a scene in the film where Fauja sits down on some steps with his marathon relay team at the end of the Edinburgh marathon. They laugh and joke and one of them ribs him for looking as tired as if he had been working in the fields in Punjab. He slaps Fauja's knee and drags him down a step, they all burst out laughing and it is a funny and touching scene. It perfectly encapsulates the man and visually reaffirms a memorable Fauja quote from the film; 'I get younger as I get older'.

My experience making the film was truly life-changing. After each film screening I have been always approached by my members of the audience who are moved and inspired by Fauja. I am privileged to have made a

film on this charismatic and inspiring man who truly is a testament to 'nothing is impossible' in life.

Nirbhai Singh (Germany). Nirbhai was at the forefront when Fauja visited Frankfurt to run in a relay in 2010

Sardar Fauja Singh's respect for Guru Granthji and his belief in Akaal Purkh (God), attitude of embracing all people, crystal clear mind, dedication towards his aim, love for his health and nature, undeterred courage, enmity for none and laud voice at 99 reflects clearly a pious soul, i.e. God in him. His body is a wonderful creation of Akaal Purkh. He is determined to promote natural gift of *kes* (hair) covered with turban on our planet earth. His personality is a source of inspiration for all male and female, young and old. May Akaal Purkh always bless him with good health, vigour and long life and may he always be remembered as a true Sikh.

From the Metropolitan Police Sikh Association

The Asian community in the United Kingdom lacks good role models, every now and then someone will spring up for a short period only to disappear into the English establishment through the honours system. Once they get a 'gong' they believe that they can no longer be part of the Asian community but assimilate themselves to high or upper middle class White community; but the humble mirror cannot tell a lie. There are others who use the Asian community for their own greed and self-importance thereby trampling on the hardworking, unrecognised people who get out of bed in order to do good not only for themselves but also for the community. However, Fauja Singh was a case different; here was one of the good guys.

Over the years there has been one person who has stayed within the Asian community and has kept to humble ways of life, given away his gains to charity and continues to be an excellent role model for all ages. Fauja Singh, the most famous Sikh marathon runner, is indeed a true celebrity.

Members of the Metropolitan Police Sikh Association are proud of Fauja Singh. We decided to use Fauja's 2004 Adidas advert for our annual report. As a police service we always promoted health and well-being. Fauja Singh leads by example as eats a simple healthy diet and does not drink or smoke.

2011 will be a special year as it marks his 100th birthday, a great achievement in life.

Harbinder Singh Rana, Director, Anglo Sikh Heritage Trail

'Despite his own advancing years Fauja Singh has energised and rejuvenated the Sikhs of the UK. His cheerful disposition, smiling eyes, and charming modesty have made him a legendary figure. He effortlessly exudes the stamina and discipline required of marathon runners yet comes across as a most unexpected athlete. He has done much to elevate the image of the Sikhs in the Western eyes and for that alone he is something who can be proudly called a national treasure.'

The Singh Twins: An Artist's Tribute to Sardar Fauja Singh

As a world record holder Marathon runner in his 90's who is now celebrating his 100th birthday and still showing no signs of slowing down on the goals he has set for himself, Sardar Fauja Singhji is not just a remarkable role model in the world of sport, he also stands tall among people of his age group and the Sikh community from which he comes.

His sporting success, spirit, energy and determination are an inspiration to all and actually proving what can be achieved with positive attitude, dedication, focus and commitment – a lesson that can be applied to any aspect of life.

Behind the serious sportsman with a serious message of healthy living who famously became probably one of the most distinctive faces of Adidas's 'Impossible is Nothing' campaign, is a fun loving and humble man with a generous heart who, in the true spirit of the Sikh ideal of *sewa* (service of others), donates every penny he raises through running to charity.

It was these qualities and achievements, which led us to include Sadar Fauja Singhji in a new painting which we were commissioned to create in 2010 for the Museum of London's newly opened Galleries of Modern London. We honoured him by reserving a pride of place for him, i.e. at the centre of a scene representing the unique contributions and positive impact of Indians to British life and mainstream culture. We feel very privileged to know someone whose shining example has touched our lives and we know, will continue to touch the lives of many others as well.

T. Sher Singh, Editor, www.sikhchic.com

'In a day and age in which the world has few heroes, Fauja Singh stands head-and-shoulders above us all...as a giant humble human spirit. It's not just his physical prowess or the fact that he is off running marathons while contemporaries and juniors have long given up on life. It's not just that he can shrug off feats of strength and stamina as mere routine, which all of us, no matter what our age or orientation, would deem herculean. It's not just that he goes on and on effortlessly, like the famous Energiser bunny in a popular TV commercial.

'What sets him apart from much of the world is his humility – true, unadulterated humility – in the face of fame and fortune, both of which he pushes away with ease and disdain.

'It's his sweetness of speech – simple, down-to-earth, unpretentious, unpreachy, without judgement.

'It's his limitless faith in God and humanity.

'It's the total absence of ego in his actions: there is no agenda, no plan and no destination; only the sheer joy of living.

'It's his infectious humour – a *chardi kalaa* which inspires all who taste it to greater heights.

'It's his constant giving and giving to all who ask and need.

'It's in his ability, like no other man or woman I know, to make everything seem within reach. It's the very essence of his life – that everything is do-able and nothing is impossible.

'If only there was some way he could touch us all, one by one – like Midas of yore – and turn us into men and women, boys and girls, like himself…blessed with endless hope and joie de vivre!'

David Bedford, Race Director of the Virgin London Marathon

Congratulations to Fauja Singh on his amazing marathon running efforts over the many years. Fauja has run in the London Marathon five times, always with great enthusiasm, and with great applause from the crowds lining the streets, and we look forward to welcoming him on the streets of London once again in the future.

APPENDIX 2

Prescription for Aspiring Long Distance Runners

The basic warm up (and cool down).

Neck Roll

Stand in upright position with arms relaxed by the side.

Slowly roll your head in a clockwise direction six times while breathing normally.

Slowly roll your head in an anti-clockwise direction six times while breathing normally.

Arm Stretch

Stand in upright position with arms relaxed by the side.

Extend your arms to form a crucifix position with the index fingers pointing away.

While keeping your head in a fixed position facing forward, slowly start rotating both arms clockwise and simultaneously increasing the

size of the circle until the arms are stretched maximum while breathing normally.

Rotate the stretched arms three times before slowly dropping them until the original crucifix position is reached. Keep the elbows locked at all times and breathe normally.

Repeat points (3) and (4) in anti-clockwise direction.

Spine Stretch

Stand in upright position with arms relaxed by the side.

Extend your arms to form a ready to dive position with the fingers pointing away.

While keeping your head in a fixed position facing forward, swing your arms fast from left to right and back again, keeping the elbows above shoulder height as if skimming above the water in a swimming pool..

Repeat point (3) a dozen times while breathing normally.

Side Stretch

Stand in upright position with arms relaxed by the side.

Widen your legs as if on a surfboard, i.e. approximately two feet apart.

Keeping your back straight, slowly lean to the left by sliding your left hand along the thigh as far as you can while allowing your right hand slide up your right side.

Slowly straighten up to get to point (1).

Repeat point (3) but lean to the right.

Repeat points (3) to (5) five more times breathing normally throughout.

Hip Flex

Stand in upright position with arms relaxed by the side.

Extend your arms to form a ready to dive position with the fingers pointing away.

Spread your legs as far apart as comfort allows.

Lean forward to touch the ground in front of you as far away from your feet as possible.

Straighten up to an upright position.

Lean forward to touch the ground in between your legs.

Straighten up to an upright position.

Lean forward and try to touch the ground as far behind the feet line as possible.

Straighten up to an upright position.

Repeat points (4) to (9) five more times breathing normally throughout.

Knee Lifts

Stand in upright position with arms relaxed by the side.

Keeping your elbows tucked by your side, lift your forearms with the palms facing down to a point where your hands are at the height of your hips.

Standing on your left leg, lift your right knee up slowly until it touches your hand and slowly put it down to achieve position as in point (2).

Standing on your right leg, lift your left knee up slowly until it touches your hand and slowly put it down to achieve position as in point (2).

Repeat points (4) and (5) five more times each.

Step Ups

Stand in the road in an upright position with arms relaxed by the side with your toes one inch away from the kerb.

Leading with the left leg, step up to the top of the kerb and bring right foot to join the left foot on top of the kerb.

Leading with the left leg, step down to the road and bring right foot to join the left foot on to the road.

Repeat points (2) and (3) as fast as you can atleast thirty times while breathing normally.

Repeat points (2), (3) and (4) but leading with the right leg thirty times while breathing normally.

This completes the warm up schedule

What has been achieved is the systematic stretching from the neck down to the ankles while getting your heart warmed up for the run.

Taking a sip of water just before setting off for the run is not harmful. A sip of water or any energy drink if had after completing every mile, whether one needs it or not will help the body replenish the fluids lost during running.

At the end of the run, the cool down is a repeat of the above but with extra stretching of the legs as pushing against the wall while leaning forward.

Also, drink any fizzy drink which is at room temperature with a pinch of table salt to replace the body salts lost during training through perspiration.

Ideally, if you have about six to nine months to train for a marathon, use a three stage method:

Getting started (up to 5km)

Getting confident (up to 10km)

Getting real (from 10km to full marathon).

The Get-Started Schedule
From naught to 30 minutes in 8 weeks

According to the level of fitness, one should comfortably be able to build from nothing to running continuously for 30 minutes in the space of eight weeks. All one needs is commitment to run at least three times a week and follow this routine regularly.

A few things to keep in mind

Allow at least a day between runs when you begin.

If in doubt, slow down. You should be able to hold a conversation while you run. Respecting your body is the best route to progression.

Walk purposefully, and be strict with your run/walk timings.

Do not be afraid to repeat a week, or drop a week. Everyone is different.

Have faith. You **will** get there!

The Schedules

Week 1 Run one min, walk 90 seconds. Repeat eight times. Do three times a week.

Week 2 Run two mins, walk one min. Repeat seven times. Do three times a week.

Week 3 Run three mins walk one mins. Repeat six times. Do three times a week.

Week 4 Run five mins, walk two mins. Repeat four times. Do three times a week.

Week 5 Run eight mins, walk two mins. Repeat three times. Do three times a week.

Week 6 Run 12 mins, walk one min. Repeat three times. Do three times a week.

Week 7 Run 15 mins, walk one min, Run fifteen mins. Do three times a week

Week 8 Run 30 mins continuously.

The Result

Congratulations! You're a real runner now! What next? How about:

A Beginner's Schedule for 5km in 6 weeks

Week One

Mon Rest
Tue Run 1 min, walk 1 min. Do 10 times
Wed Rest
Thu Run 2 mins, walk 4 mins. Do 5 times
Fri Rest
Sat Rest
Sun Run 2 mins, walk 4 mins. Do 5 times

Week Two
Mon Rest
Tue Run 3 mins, walk 3 mins. Do 4 times
Wed Rest
Thu Run 3 mins, walk 3 mins. Do 4 times
Fri Rest
Sat Rest
Sun Run 5 mins, walk 3 mins. Do 3 times

Week Three
Mon Rest
Tue Run 7 mins, walk 2 mins. Do 3 times
Wed Rest
Thu Run 8 mins, walk 2 mins. Do 3 times
Fri Rest
Sat Rest
Sun Run 8 mins, walk 2 mins. Do 3 times

Week Four
Mon Rest
Tue Run 8 mins, walk 2 mins. Do 3 times

Wed Rest
Thu Run 10 mins, walk 2 mins. Do twice then run for 5 mins
Fri Rest
Sat Rest
Sun Run 8 mins, walk 2 mins. Do 3 times

Week Five
Mon Rest
Tue Run 9 mins, walk 1 min. Do 3 times
Wed Rest
Thu Run 12 mins, walk 2 mins. Do twice then run for 5 mins
Fri Rest
Sat Rest
Sun Run 8 mins, walk 2 mins. Do 3 times

Week Six
Mon Rest
Tue Run 15 mins, walk 1 min. Do twice
Wed Rest
Thu Run 8 mins, walk 2 mins. Do 3 times
Fri Rest
Sat Rest
Sun 5km Race!

On the day of the race

You will probably realise that you can run at least 20 minutes before you need a break, but whatever your plan, start slowly, and do not wait until you are exhausted before taking one-minute walk breaks.

Be confident

Once you have got this far it is great, that you have persevered to date, I guess you are now ready to move on to the next stage – 10km run (6.23 miles). You can safely forget about running in terms of minutes

alone as you can combine self-motivation with running to set distances also to help with achieving high performance paced running so as to set personal bests.

Re: 10 Km in five weeks Running Schedule

Two aspects – first the phases – one for each week until the race.

Week One: Mileage Base Running for Aerobic Endurance.

Beginner runners need speedplay to remind them how to run properly; all runners need speed training for proper running and for muscle stimulation especially during the high mileage training which builds base. Low level aerobic exercise is the safest way to build aerobic endurance for running. Run at 60-70 percent of your aerobic capacity to increase your oxygen assimilation, but include speedwork to maintain economical running form.

Week Two: Add Strength to your Running Foundation with Hills.

Hill training does not have to be gruesome. Build strength by adding one half mile of hill running each week for four weeks. Add resistance to your muscles by running steeper hills and through mud or sand. Hill running is not the only way to build running muscle strength; weight training also improves your running.

Week Three: Run more Efficiently; Stimulate more Muscle Cells.

Stimulate better aerobic running ability, better anaerobic running ability, and better use of your entire muscle cell to make and use energy efficiently. Cruise intervals and tempo running improve your running coordination and teach you to run relaxed at a fast pace. Run 15 seconds per mile SLOWER than 10km race pace for a huge training affect.

Week Four: Pace Perfection. Training at 5 km and 2 Mile Race Pace.

Recreational and experienced runners should train at 5K pace to improve VO2 maximum to run faster 5Ks and 10Ks. It starts with running a few strides. You ease up to short intervals on even surfaces.

Week Five: How to Peak. Perfecting the previous four weeks training.

Rest is one factor in peaking for a 5K or 10K race, but so is the prudent use of long reps at 5K pace. In long interval running, more of your running time is spent in your high VO2 max training zone. You will have to run efficiently to maintain the fast pace, about 10 seconds per mile faster than race pace.

Now the second aspect

Week	Mon	Tue	Wed	Thu	Fri	Sat	Sun
1	20 min jog		30 min jog with sprint every 5 min		30 min jog		40 min jog with sprint every 5 min
2		30 min run up hill		40 min run up hill and jog down		50 min jog up and down hill	
3	30 min run at 90% of fast running		40 min run at 80% of fast running		50 min run at 75% of fast running		60 min run at 75% of fast
4		Run 2 miles fast as possible		Run 3 miles as fast as		Run 4 miles as fast as	
5	Run 5 miles as fast as possible		Run 4 miles as fast as possible		Run 4 miles at 80% of fast running		Race

After successful completion of the said schedule, one may follow one of three options:

1. The classic 24 week plan
2. The shorter 24 week plan or
3. The quick 12 week plan where you just follow the even numbered week schedules as below.

24 Week Classic Training Plan for sub 5 Hour Marathon

WEEK 1

MON	Jog 15 mins
TUES	Jog 15 mins
WED	Jog 10 mins, Walk 10, Jog 5
THURS	Jog 15 mins
FRI	Jog 15 mins, Walk 5, Jog 10
SAT	REST
SUN	Jog 20 mins

WEEK 2

MON	Jog 15 mins
TUES	Jog 20 mins
WED	Jog 15 mins, Walk 10, Jog 10
THURS	Jog 20 mins
FRI	Jog 15 mins, Walk 5, Jog 15
SAT	REST
SUN	Jog 30 mins

WEEK 3

MON	Jog 20 mins
TUES	Jog 25 mins
WED	Jog 10 mins, Run 5, Jog 15
THURS	Jog 25 mins
FRI	Jog 15 mins, Run 8, Jog 15

SAT	REST
SUN	Jog 40 mins
WEEK 4	
MON	Jog 20 mins
TUES	Jog 30 mins
WED	Jog 10 mins, Run 10, Walk 5, Run 5, Jog 10
THURS	Jog 25 mins
FRI	Jog 15 mins, Run 10, Jog 20
SAT	REST
SUN	Jog 50 mins
WEEK 5	
MON	Jog 30 mins
TUES	Jog 35 mins
WED	Jog 5 mins, Run 10, Jog 5, Run 5, Jog 15
THURS	Jog 25 mins
FRI	Jog 15 mins, Run 10, Walk 5, Jog 15, Run 10, Walk 5, Jog 15
SAT	REST
SUN	Jog 60 mins
WEEK 6	
MON	Jog 40 mins
TUES	Jog 40 mins
WED	Jog 5 mins, Run 10, Jog 5, Run 10, Jog 20
THURS	Jog 30 mins
FRI	Jog 10 mins, Run 10, Jog 10, Run 10, Jog 15, Run 5, Jog 20
SAT	REST
SUN	Jog 70 mins
WEEK 7	
MON	Jog 40 mins
TUES	Jog 45 mins
WED	Jog 5 mins, Run 15 Jog 15, Run 10, Jog 20, Run 5, Jog 15
THURS	Jog 35 mins
FRI	Jog 5 mins, Run 15, Jog 20, Run 5, Jog 10, Run 5, Jog 20

SAT	REST
SUN	Jog 75 mins
WEEK 8	
MON	Jog 40 mins
TUES	Jog 45 mins
WED	Jog 10 mins, Run 15, Jog 20, Run 15, Walk 5, Jog 25
THURS	Jog 40 mins
FRI	Jog 60 mins
SAT	REST
SUN	Jog 20 mins, Run 15, Jog 15, Run 10, Jog 35
WEEK 9	
MON	Jog 25 mins
TUES	Jog 45 mins
WED	Jog 15 mins, Run 15, Jog 15, Run 15 Walk 5, Jog 10, Run 5, Jog 15
THURS	Jog 25 mins
FRI	Jog 70 mins
SAT	REST
SUN	Jog 10 mins, Run 20, Walk 10, Jog 25, Run 10, Walk 3, Jog 25
WEEK 10	
MON	Jog 30 mins
TUES	Jog 60 mins
WED	Jog 10 mins, Run 10, Jog 15, Run 10, Jog 20, Run 10, Walk 3, Jog 25
THURS	Jog 25 mins
FRI	Jog 15 mins, Run 10, Jog 45
SAT	REST
SUN	Jog 5 mins, Run 15, Walk 3, Run 5, Walk 3, Jog 60
WEEK 11	
MON	Jog 25 mins
TUES	Jog 60 mins
WED	Jog 20 mins, Run 20, Walk 3, Run 10, Walk 3, Jog 40

THURS	Jog 25 mins
FRI	Jog 10 mins, Run 10, Jog 20, Run 5, Jog 20
SAT	REST
SUN	Jog 25 mins, Run 10, Jog 25, Run 5, Jog 35, Run 10, Jog 30, Run 5, Walk 3 Jog 20

WEEK 12

MON	Jog 15 mins, Walk 5, Jog 10
TUES	Jog 60 mins
WED	Jog 10 mins, Run 10, Jog 30
THURS	Jog 30 mins
FRI	Jog 15 mins
SAT	REST
SUN	RACE – Half Marathon.

WEEK 13

MON	If participated in the race – Rest; if not – Jog 30 mins
TUES	Jog 30 mins
WED	Jog 45 mins
THURS	Jog 30 mins
FRI	Jog 60 mins
SAT	REST
SUN	Jog 90 mins

WEEK 14

MON	Jog 30 mins, Walk 5, Run 10, Jog 10
TUES	Jog 45 mins
WED	Jog 10 mins, Run 15, Jog 20, Run 10, Jog 20
THURS	Jog 30 mins
FRI	Jog 10 mins, Run 10, Jog 30, Run 15, Jog 45
SAT	Walk 15 mins
SUN	Jog 90 mins

WEEK 15

| MON | Jog 15 mins |
| TUES | Jog 35 mins, Run 30, Jog 30, Walk 10 |

WED	Jog 15 mins
THURS	Jog 10 mins, Run 10, Jog 40, Walk 10, Jog 5 Run 5, Jog 10
FRI	Jog 20 mins
SAT	Jog 10 mins, Walk 10
SUN	Jog 10 mins, Run 10, Walk 3 Repeat x 5 – Total 115 mins
WEEK 16	
MON	Jog 20 mins
TUES	Jog 40 mins
WED	Jog 20 mins, Run 15, Walk 10, Run 20, Jog 15, Run 15, Walk 5, Jog 10
THURS	Jog 20 mins Walk 10
FRI	Jog 45 mins
SAT	REST
SUN	Jog 20 mins, Run 10, Walk 5 Repeat x 3
WEEK 17	
MON	Jog 20 mins, Walk 10
TUES	Jog 40 mins
WED	Jog 5 mins, Run 15, Jog 60
THURS	Jog 30 mins
FRI	Jog 60 mins
SAT	REST
SUN	Jog 15 mins, Run 10, Jog 100
WEEK 18	
MON	REST
TUES	Jog 15 mins
WED	Jog 45 mins
THURS	Jog 60 mins
FRI	Jog 30 mins
SAT	REST
SUN	Jog 90 mins
WEEK 19	
MON	Jog 30 mins

TUES	Jog 10 mins, Run 10, Jog 20, Run 10, Jog 60
WED	Jog 45 mins
THURS	Jog 20 mins, Run 5, Jog 35
FRI	Jog 60 mins
SAT	REST
SUN	Jog 150 mins

WEEK 20

MON	REST
TUES	Jog 15 mins, Walk 10, Jog 10
WED	Jog 60 mins
THURS	Jog 10 mins, Run 10, Jog 10 Repeat x 3
FRI	Jog 30 mins, Walk 10
SAT	REST
SUN	Jog 60 mins

WEEK 21

MON	Jog 45 mins
TUES	Jog 10 mins, Run 10, Jog 25
WED	Jog 10 mins, Run 10, Jog 60
THURS	Jog 5 mins, Run 5, Sprint 30 sec, Walk 3 mins, Repeat x 4
FRI	Jog 45 mins
SAT	REST
SUN	Jog 60 mins, Walk 15, Jog 60, Walk 15, Jog 30

WEEK 22

MON	REST
TUES	Jog 30 mins
WED	Jog 30 mins
THURS	Jog 60 mins
FRI	Jog 30 mins
SAT	REST
SUN	Jog 10 mins, Run 10, Jog 15, Run 15, Walk 3 Repeat x 3

WEEK 23

MON	Walk 15 mins

TUES	Jog 30 mins
WED	Jog 90 mins, Run 10
THURS	Jog 60 mins
FRI	Jog 30 mins
SAT	REST
SUN	Jog 120 mins
WEEK 24	
MON	Jog 15 mins, Walk 5, Jog 10
TUES	Jog 45 mins
WED	Jog 70 mins
THURS	Jog 15 mins, Walk 10
FRI	Walk 15 mins
SAT	REST
SUN	RACE

24 Week Short Training Plan for sub 5 Hour Marathon

WEEK 1	
MON	Jog 15 mins Walk 10, Jog 5
WED	Jog 10 mins, Walk 10, Jog 10
FRI	Jog 15 mins, Walk 5, Jog 10
SUN	Jog 20 mins Walk 10, Jog 15
WEEK 2	
MON	Jog 15 mins
WED	Jog 25 mins, Walk 10, Jog 10
FRI	Jog 25 mins, Walk 5, Jog 15
SUN	Jog 35 mins, Walk 5, Jog 20
WEEK 3	
MON	Jog 20 mins
WED	Jog 30 mins, Run 5, Jog 15

| FRI | Jog 15 mins, Run 10, Jog 15 |
| SUN | Jog 40 mins, Run 10, Jog 10 |

WEEK 4

MON	Jog 20 mins
WED	Jog 10 mins, Run 10, Walk 5, Run 5, Jog 10
FRI	Jog 25 mins, Run 10, Jog 20
SUN	Jog 50 mins, Run 10, Jog 10

WEEK 5

MON	Jog 30 mins
WED	Jog 15 mins, Run 10, Jog 5, Run 15, Jog 15
FRI	Jog 15 mins, Run 10, Walk 5, Jog 15, Run 10, Jog 15
SUN	Jog 60 mins

WEEK 6

MON	Jog 40 mins
WED	Jog 15 mins, Run 15, Jog 15, Run 10, Jog 20
FRI	Jog 15 mins, Run 15, Jog 10, Run 20, Jog 25, Run 5
SUN	Jog 70 mins, Run 15

WEEK 7

MON	Jog 40 mins
WED	Jog 5 mins, Run 15 Jog 15, Run 20, Jog 20, Run 20
FRI	Jog 5 mins, Run 25, Jog 20, Run 25, Jog 10, Run 25
SUN	Jog 75 mins, Run 15

WEEK 8

MON	Jog 40 mins
WED	Jog 10 mins, Run 25, Jog 20, Run 30, Walk 5, Jog 25
FRI	Jog 60 mins
SUN	Jog 20 mins, Run 30, Jog 15, Run 30, Jog 45

WEEK 9

MON	Jog 25 mins
WED	Jog 15 mins, Run 30, Jog 15, Run 45, Walk 5, Jog 10,
FRI	Jog 70 mins
SUN	Jog 10 mins, Run 40, Walk 10, Jog 25, Run 30, Walk 5

WEEK 10

MON	Jog 30 mins
WED	Jog 10 mins, Run 45, Jog 15, Run 30, Jog 20, Run 10
FRI	Jog 15 mins, Run 45, Jog 45
SUN	Jog 5 mins, Run 55, Walk 5, Run 15, Walk 5, Jog 60

WEEK 11

MON	Jog 25 mins
WED	Jog 20 mins, Run 60, Walk 5, Run 10, Jog 40
FRI	Jog 10 mins, Run 10, Jog 20, Run 20, Jog 20
SUN	Jog 25 mins, Run 30, Jog 25, Run 45, Jog 35, Run 10,

WEEK 12

MON	Jog 15 mins, Walk 5, Jog 10
WED	Jog 10 mins, Run 60, Jog 30
FRI	Jog 45 mins
SAT	REST
SUN	RACE – Half Marathon.

WEEK 13

MON	If participated in the race – Rest; if not – Jog 30 mins
WED	Jog 45 mins
FRI	Jog 60 mins
SUN	Jog 90 mins

WEEK 14

MON	Jog 30 mins, Walk 5, Run 10, Jog 10
WED	Jog 10 mins, Run 25, Jog 20, Run 20, Jog 20
FRI	Jog 10 mins, Run 30, Jog 30, Run 15, Jog 45
SUN	Jog 100 mins

WEEK 15

MON	Jog 15 mins
WED	Jog 45 mins
FRI	Jog 10 mins, Run 30, Jog 40, Walk 10, Jog 20
6UN	Jog 10 mins, Run 10, Walk 5 Repeat x 5

WEEK 16

MON	Jog 20 mins
WED	Jog 20 mins, Run 15, Walk 10, Run 20, Jog 45
FRI	Jog 75 mins
SUN	Jog 20 mins, Run 20, Walk 5 Repeat x 3

WEEK 17

MON	Jog 20 mins, Walk 10
WED	Jog 5 mins, Run 15, Jog 60
FRI	Jog 60 mins
SUN	Jog 15 mins, Run 45, Jog 100

WEEK 18

MON	REST
WED	Jog 45 mins
FRI	Jog 60 mins
SUN	Jog 90 mins

WEEK 19

MON	Jog 30 mins
WED	Jog 10 mins, Run 10, Jog 20, Run 20, Jog 60
FRI	Jog 60 mins
SUN	Jog 150 mins

WEEK 20

MON	REST
WED	Jog 15 mins, Walk 10, Jog 10
FRI	Jog 10 mins, Run 10, Jog 10 Repeat x 3
SUN	Jog 60 mins

WEEK 21

MON	Jog 45 mins
WED	Jog 10 mins, Run 10, Jog 60
FRI	Jog 100 mins
SUN	Jog 60 mins, Walk 15, Jog 60, Walk 15, Jog 30

WEEK 22

MON	REST
WED	Jog 30 mins

FRI	Jog 60 mins
SUN	Jog 15 mins, Run 45, 3 Repeat x 3
WEEK 23	
MON	Walk 15 mins
WED	Jog 90 mins, Run 30
FRI	Jog 120 mins
SUN	Jog 150 mins
WEEK 24	
MON	Jog 15 mins, Walk 5, Jog 10
WED	Jog 60 mins
FRI	Walk 15 mins
SAT	REST
SUN	RACE

In 2004, Adidas had brought out a brochure with Fauja Singh on the cover page. The brochure that had featured other personalities as well also carried valuable tips for marathon runners. Since the aim of the book is also to motivate and educate people to run for a healthy life, a few do's and don'ts on the day of the run and its eve are shared for readers' benefit.

1. Don't be a hero if you have trained for a 10 kilometres race, don't enter a marathon.
2. Preparation starts the night before. Don't participate in anything new that you are not accustomed to. Layout your kit including a change of clothes.
3. Eat a high-carbs meal for dinner.
4. Eat a high-carbs breakfast 2-4 hours before the race starts. Cereal, toast, seasonal fruits are beneficial. Drink plenty of water/sports drinks till an hour of race remains to start, especially if there aren't many water stations on course. Practice before in-training.
5. Buy seam free socks.

6. Stretch and warm up. With half an hour to go, get your heart rate up with 10-20 minutes light running/fast/walking/stretching.

7. Use the toilet.

8. Hit the start area with about ten minutes to go. If you are not sure of your pace, start towards the back.

9. Starts can be chaotic so stay calm.

11. Take a drink from every station. Over hydration is rarely a problem.

12. Smile for the finishing line cameras!

APPENDIX 3

Individuals and Organisations that have Supported and Recognised Fauja's Efforts

Her Majesty, Queen Elizabeth II
His Holiness the XIV Dalai Lama
President Pervez Musharraf – Former Pakistan President.
Captain Amarinder Singh – Former CM of Punjab
Alan Brookes – Race Director of Toronto Waterfront Marathon.
Jeevan Singh Mangat of GMS Ltd in Ilford
Bhai Sahib Mohinder Singh – Nishkam SevakJatha
Brendan Foster – Race Director Great North Run
Carlos Moya – Lisbon Half Marathon, Marketing
Chris Barrand – ADIDAS
Damian O'Looney – Race Director of Edinburgh Marathon
Dave Bedford – Race Director of London Marathon
Eric Francois – Race Director Luxembourg Marathon
Frank Clements – Race Director Glasgow Half Marathon
Fred Lebow – New York Marathon Chief
Ian Ladbrook – Lahore Marathon
Jackie Glazebrook – BLISS Charity
Jo Schindler – Race Director Frankfurt Marathon

Jochen Haase – ADIDAS

Leveke Lambersy – ADIDAS

Malcolm McCosker – London Independent Hospital

Marty Wanless – Association of International Marathons

Suky Thakur and Amrik Singh Bansal, Ilford

Harbinder Singh Rana, Maharja Duleep Singh Centenary Trust

T Sher Singh, Editor-sikhchic.com

Dr. Tinna and Mr Baldev Singh Shergill, New York/Sikhs In America

Kulvinder Singh Jabble, West London

Suky Thakur and Amrik Singh Bansal, Ilford

British Telecom – Living Legends Award

Council of Gurdwaras – South East

Guru Gobind Singh Children's Foundation in Canada

The India International Foundation

Scottish Asian Sports Association

Sikh Directory – Lifetime Achievement Award

Sikh Sports Association of USA

Sikhs In England (SIE)/Sikhs Sports Association (UK)/Sikhs In The City

Sri Chinmoy Peace Relay Run Award

Vaisakhi on the Square Committee

ENDNOTES

Chapter 7: Running

1. The length of a marathon was not fixed at first, since the only important factor was that all athletes competed on the same course. The marathon races in the first few Olympic Games were not of a set length, but were approximately 40 kilometres (25 miles), roughly the distance from Marathon to Athens by the longer, flatter route. The exact length of the Olympic marathon varied depending on the route established for each venue. The standard distance for the marathon race was set by the International Amateur Athletic Federation (IAAF) in May 1921 at a distance of 42.195 kilometres (26 miles, 385 yards). Rule 240 of their Competition Rules specifies the metric version of this distance. This seemingly arbitrary distance was then adopted for the marathon at the 1908 Summer Olympics in London. At a meeting of the International Olympic Committee in The Hague in May 1907, it was agreed with the British Olympic Association that the 1908 Olympics would include a marathon of about 25 miles or 40 kilometres. In November 1907, a route of about that distance was published in the newspapers, starting at Windsor Castle and finishing at the Olympic Stadium, the Great White City Stadium in Shepherd's Bush in London. There were protests about the final few miles because of tram-lines and cobbles, so the route was revised

to cross the rough ground of Wormwood Scrubs. This lengthened the route, as did plans to make the start 700 yards (640 m) from Queen Victoria's statue by Windsor Castle, and it was decided to fix the distance at 26 miles (42 km) to the stadium, plus a lap of the track (586 yards, 2 feet), using the Royal Entrance as the marathon tunnel, and finishing in front of the Royal Box. For the official Trial Marathon on 25 April 1908, organized by the Polytechnic Harriers, the start was on 'The Long Walk' – a magnificent avenue leading up to Windsor Castle in the grounds of Windsor Great Park. For the Olympic Marathon itself,the start was on the private East Terrace of Windsor Castle, with the permission of King Edward VII, so that the public would not interfere with the start. The Princess of Wales and her children drove from their home at Frogmore on the far side of Windsor Great Park to watch the start of the race. Shortly before the Games opened, it was realized that the Royal Entrance could not be used as the marathon entrance – it was raised to permit easy descent by the royal party from their carriages, and did not open onto the track – so an alternative entrance was chosen, diagonally opposite the Royal Box. A special path was made just outside the Franco British Exhibition ground so that the distance to the stadium remained 26 miles. The finishing line was to 385 yards, and the total distance became 26 miles 385 yards (42.195 km). Left unchanged, but in order that the spectators, including Queen Alexandra, could have the best view of the final yards, the direction of running was changed to 'right-hand inside' (i.e. clockwise). This meant the distance in the stadium was shortened).

Chapter 9: First Marathon

1. Set over a largely flat course around the River Thames, the London Marathon is generally regarded as a very competitive and unpredictable event, and is the only Marathon course in the world that is run in two hemispheres, both the East and West, as the full course crosses

the Prime Meridian in Greenwich. The course begins at three separate points around Blackheath at 35 m (115 ft) above sea level, on the south of the River Thames, and heads east through Charlton. The three courses converge after 4.8 km (3 miles) in Woolwich, where the Royal Artillery Barracks is passed. As the runners reach the 6-mile (9.6 km) mark, they pass by the Old Royal Naval College and head towards Cutty Sark dry-docked in Greenwich. Heading next into Surrey Quays in the Docklands, and out towards Bermondsey, competitors race along Jamaica Road before reaching the half-way point as they cross the Tower Bridge. Running east again along The Highway through Wapping, competitors head up towards Limehouse and into Mudchute in the Isle of Dogs via Westferry Road, before heading into Canary Wharf. As the route leads away from Canary Wharf into Poplar, competitors run west down Poplar High Street back towards Limehouse and on through Commercial Road. They then move back onto The Highway, onto Lower and Upper Thames Streets.. Heading into the final leg of the race, competitors pass St Paul's Cathedral on Ludgate Hill. In the penultimate mile along The Embankment, the London Eye comes into view, before the athletes turn right into Birdcage Walk to complete the final 352 m (385 yards), catching the sights of Big Ben and Buckingham Palace, and finishing in The Mall alongside St. James's Palace. This final section of the route will form part of the 2012 Olympic Marathon Course. Since the first marathon, the course has undergone very few route changes. In 1982, the finishing post was moved from Constitution Hill to Westminster Bridge due to construction works. It remained there for twelve years before moving to its present location at The Mall. In 2005, the route around the Isle of Dogs between 22 (14) and 34 km (21 miles) was switched from a clockwise to an anti-clockwise direction, and at 35 km (22 miles) the route was diverted to avoid the cobblestoned area near the Tower of London. In 2008, a suspected gas leak at a pub in Wapping diverted the course, but in 2009 the race followed the same path as in 2007. During the 2001 Foot-and-Mouth crisis

which closed access to much of England's countryside, the London Marathon route emerged as one of the most popular urban rambling routes.

Chapter 11: Sikh Poster Boy

1. The oldest man to complete a marathon was the Greek runner Dimitrion Yordanidis, aged 98, in Athens in 1976. He finished in seven hours 33 minutes. The oldest woman to complete a marathon was Jenny Wood-Allen who completed the London Marathon at the age of 90 in 2002. She finished in 11 hours and 34 minutes.

Chapter 12: Catch-22

1. By 9:15pm on Saturday 15 May 2010, there is a very good chance that Fauja Singh will have set a new world record in the men over 95 half marathon category. His coach Harmander Singh who will be running the full marathon distance has left the responsibility of accompanying Fauja over the half marathon distance to his deputy, Nirmal Singh Lotay.

 Fauja Singh already holds more than a dozen world, Commonwealth, European and UK records from 100m to the full marathon in the men over 90 category but has now started setting new records in the men over 95 bracket – simply by just completing the distances given his age.

 This can be seen from a brief synopsis of Fauja Singh's running record. Fauja Singh already holds the 10,000m record (64 minutes – Lahore Marathon January 2005), 1/2 Marathon (2 hours 29 minutes and 59 seconds) and the Marathon record (5 hours 40 minutes and 1 second) both at the Toronto Waterfront Marathon in September 2004 and September 2003 respectively)

INDEX